The *New* Scratchboard

*Clay-Surface
Techniques and
Materials for
Today's Artists*

CHARLES EWING

Watson-Guptill Publications / New York

This book is dedicated to those with a "What if . . ." curiosity that always prevents them from exactly following a recipe.

ACKNOWLEDGMENTS

To Steve Quiller, for his refreshing optimism, endless encouragement, and practical help when I knew he would rather be painting!

To Thomas Daskam, for planting the seed that grew into my love of art and the scratchboard medium.

To my father, Frank, who, by his example, instilled in me the excitement of inventive discovery.

To Elaine Salazar, whose incredible perseverance took an invention for a new art surface and placed it in the hands of artists worldwide.

To all the artists, particularly those kind enough to submit work for this book, whose creative minds have contributed to our growing knowledge about the use of the clay art surface.

To the artists and illustrator-authors, especially Ruth Lozner, Merritt Cutler, and Cécile Curtis, whose books inspired a generation of artists, including myself, to experiment with scratchboard.

To Candace Raney, the acquisitions editor who set this project in motion.

To Robbie Capp, the editor whose professionalism eased the distillation of a rough wine into a drinkable brandy.

And especially to my wife, Barbara, who was patient enough to indulge my curiosity.

FRONTISPIECE
CHARLES EWING *Angles in Repose*
20 x 16" (51 x 41 cm). Collection of Barbara Ewing.

TITLE PAGE
CHARLES EWING *Flash of Color*
12 x 16" (31 x 41 cm). Collection of Nancy Freshour and Dick Smith.

Senior Acquisitions Editor, Candace Raney
Edited by Robbie Capp
Designed by Patricia Fabricant
Graphic Production by Hector Campbell
Text set in Scala

First published in 2001 in the United States by Watson-Guptill Publications,
a division of BPI Communications, Inc.
770 Broadway, New York, NY 10003

Catalog-in-Publication Data for this book is available from the Library of Congress.

ISBN 0-8230-4658-3

Manufactured in Malaysia

First printing, 2001
1 2 3 4 5 6 7 8 / 08 07 06 05 04 03 02 01

Contents

Foreword

I HAVE OBSERVED THE CREATION of this book long before this text was written and its artwork developed. In fact, the seeds for this book come from the very being that is Charles Ewing.

Charlie, as his friends call him, is a modern Renaissance man. He is a draftsman, a painter, and printmaker, an educator, and teacher of workshops, an outdoorsman, outfitter, and guide, and an inventor with a questioning mind. We have spent many evenings together drawing models, many days together painting the southwestern landscape, many trips together painting different regions of the world. During these times, we talk art and life, which to me are one and the same. I have learned much from this man.

He grew up in Albuquerque, New Mexico, where his father was a painter and commercial artist. He graduated from Colorado State University, majoring in wood technology, and worked for two years in the Peace Corps in Chile. He has owned an art gallery, lived in isolation in the San Juan Mountains, and now he and his wife, Barbara, live in the San Luis Valley in southern Colorado. I have known Charlie since the early 1980s and have watched his work evolving to the point that he is now an internationally collected artist. I have watched him invent, develop, and refine a clay surface for his own use, and then experiment on this surface with various techniques in black and white. With his curious mind he pushes on to play with various approaches to painting and printmaking. Some of these printmaking methods are very exciting, not that complicated, and yet totally invented by Charlie. He has pursued this art form for over twenty years.

Thus, I say his book had already been written; he just had to fill in the lines. These pages will inspire many artists to new methods, new ways to express themselves through the joy of the clay surface. I encourage all interested artists to study Charlie's book and experiment with the information given. You, too, will learn much from this man.

STEPHEN QUILLER

CHARLES EWING *Coming Home*
21 x 16" (54 x 41 cm). Collection of GeorgAnna Buckel Goe.

This is as close as I ever got to traditional scratchboard technique. The initial drawing was executed on tracing paper, chalked on the back, and then transferred to the black Essdee English Scratchboard. Most of the feather scratching was done with a homemade wire brush of clipped banjo strings glued into an old brush ferrule. An airbrush was used to gray the scratched-out whites before the final scratching.

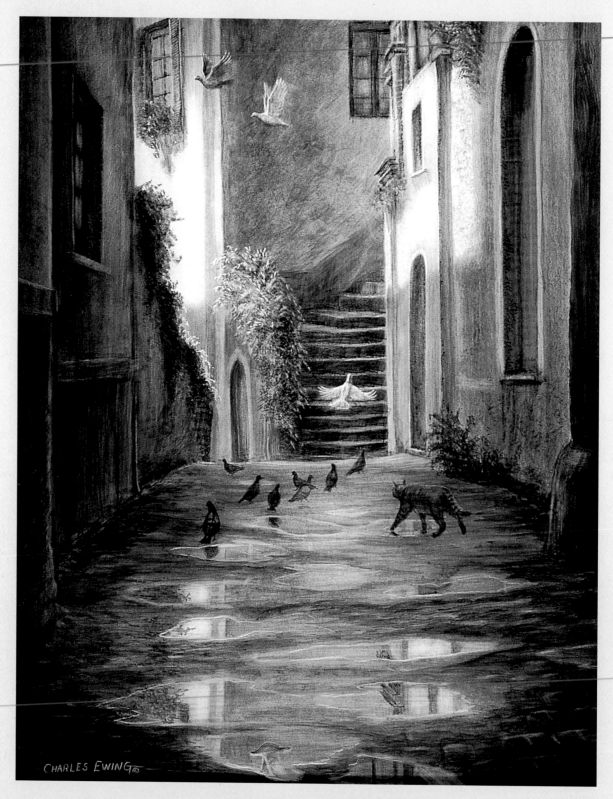

CHARLES EWING *Via di Como*
18 x 14" (46 x 36 cm). Collection of Gary and Bobbi Hochberg.
*A quiet back street in the ancient Italian village of Varenna on Lake Como, this scene
was rendered in sumi ink to better capture the feel of water in the street puddles.
Sumi ink can be redissolved and lifted or pushed around on the clay surface.*

Introduction

I WAS FIRST INTRODUCED to the existence of the clay-coated art surface called scratchboard in Santiago, Chile, by Thomas Daskam, a fine oil painter and my first instructor in the basics of drawing and painting. He suggested I might enjoy this medium upon returning to the States after my Peace Corps service ended. I was intrigued, having recalled seeing appealing scratch art in magazines. But since such materials were unavailable in Chile at that time, I had to wait three years to scratch out my first drawing on a sheet of Essdee English Scratchboard. I've been pursuing the technique ever since.

Knowing very little about the wealth of technical expertise that already existed among scratchboard illustrators, and operating under the precept that if at first you don't succeed, then you read the directions, I dove straight into the black-and-white medium, using anything and everything that would either remove ink from the clay surface or apply ink to it. To remove the ink, I used needles, razor blades, sandpaper, steel wool, sand, fiberglass insulation, tattoo needles, old dental tools inherited from my grandfather, and several kinds of homemade wire brushes, including a very good one made of clipped banjo strings. To apply the ink, I experimented with all kinds of paintbrushes, an airbrush inherited from my father, various sponges, rags, paper towels, handfuls of grass, and even long snippets of hair from my Irish setter's tail. By traditional scratchboard

standards, I was far from being labeled a purist then, and I'm afraid the little purity I had has further degenerated in the intervening years. On the other hand, in discovering what things will work, I've had a lot of fun and, I hope, have contributed toward the development of this fascinating medium of expression.

Experimenting with these new ideas led not only to innovations in rendering techniques, but also to the development, over fifteen years, of a new type of clay-surfaced panel better suited to the new ways of applying and removing ink that I had been playing with. The qualities of this surface, in turn, allowed other new approaches to scratchboard rendering, to painting with a variety of mediums, and eventually, to several new printmaking techniques. By natural progression, I believe that as new techniques evolve over time, further improvements in clay surfaces for specific techniques will enlarge the scope of possibilities that this exciting medium offers.

The creative process was not new to me. I grew up with it. I remember watching my father melt down the family toothbrushes in an attempt to make the first plastic-coated bowling pins! Well, Brunswick beat him to that one with the invention of fiberglass-coated pins, but for a while, our family could boast of some very unique plastic-coated conversation pieces. More credit to Dad; we did eventually end up with a homemade fiberglass boat. He was infected

with a bad case of inventive creativity and enjoyed every minute of it. From the sidelines, so did I, and I thank him for that.

Indeed, innovations do not represent solutions to problems nearly as much as they evidence our insatiable hunger for searching out new problems. As such, it is a phenomenon intrinsic not only to invention but also to the pursuit of art in all its forms, and occurs almost every time an artist is faced with the problems of how to communicate an inspiring idea. It is true, and thankfully so, that every new painting for every artist, amateur or professional, is at least to some degree a fresh experiment, involving new styles of expression, new techniques with known mediums, and sometimes new or improved mediums themselves. These small innovations—and every artist is responsible for a few—represent contributions to the continuum of artistic invention that stretches back thousands of years, and will likely never end.

In this book, I chronicle some of the innovations that have occurred recently in the field of clay-surface artwork. The first chapter is intended to give readers an understanding of the nature of clay surfaces; it describes those available today, the physical properties of each, and how those differences influence the artist's choice for a particular purpose. A hands-on exercise concludes this, and each successive chapter.

Next, the unique ways various tools and pigment mediums are used on clay surfaces are discussed. Many of these materials are also used on paper and canvas, but what is different about using them on a clay surface is that pigments can be applied and also *removed* with the use of tools unfamiliar to most artists, such as scratching nibs and steel wool.

In the next three chapters, I will guide you through the use of three techniques that I have developed over the years on clay surfaces, and then in the final chapter, we shall really break some new ground exploring the printmaking uses of the new clay surfaces. These fresh methods, which I have been experimenting with over the last few years, show great promise as additions to options available to professional and novice printmakers alike.

For example, new clay-coated hardboard supports can be used:

- as a delicately rendered relief printing plate;
- for intaglio-type engravings, both as a printing plate and to receive the print from a metal etching plate;
- as a "lithography" plate, requiring minimal equipment compared to traditional lithography;
- as a surface for monotype prints using both water-based paints and watercolor pencils;
- as a support for serigraph prints, both in the studio and for commercial fine-art reproduction;
- and as a surface for offset-lithography prints in full color or black and white.

Indeed, the potential for continued experimentation in all these areas is enormous. I hope that my work, and that of the many artists who graciously contributed to this book, will act as springboards for other fertile minds—and that you, the creative reader, regardless of which medium you presently work in, will join in the never-ending discovery of those clay-surface questions yet to be asked!

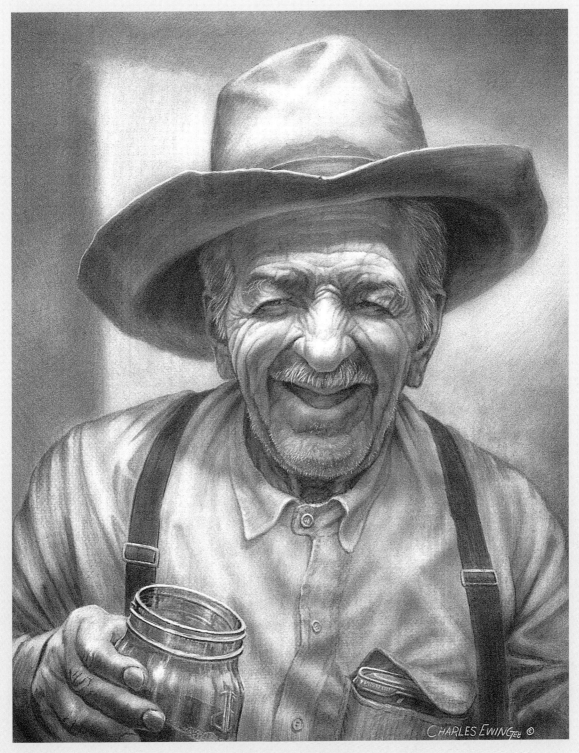

CHARLES EWING *Whiskey*
20 x 16 (51 x 41 cm).
Clay surface is ideal for portraiture using India ink. The subject's expression may be experimented on continuously—trying something, erasing it if it doesn't work, then trying something else. This elderly gentleman was full of good-humored stories of Pancho Villa. He posed for me in Guanajuato, Mexico, then later in my studio, I used a photo I had taken of him, along with my memory of his laughter, to push his facial expression to its limit.

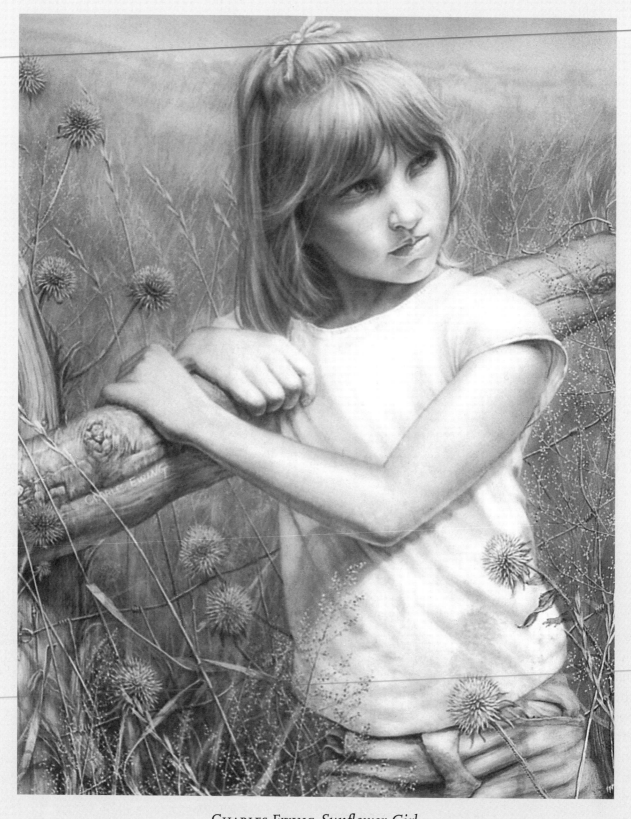

CHARLES EWING *Sunflower Girl*
India ink on white-clay surface, 24 x 20" (61 x 51 cm). Collection of Barbara Ewing.
*India ink has been applied and removed many times during the drawing process. Certain areas of the image
are pushed back, while others are pulled forward much like a sculptor would do with a piece of clay.*

1 | *The Nature of Clay-Coated Surfaces*

Out of breath, the excited young boy says, "Lion!" His father raises a questioning eyebrow. With a flash of inspiration, the boy kneels on the hard-packed earthen floor of the cave entrance and with a stick, he scratches lines in the clay that indicate "river," "side canyon," "old broken tree." With a last jab he fixes the location where he encountered the lion. The father's other eyebrow comes up in a nod of understanding as the image passes from one mind to another.

DRAWING ON EARTH; what a great communications medium! Over the millennia, scratching in sand or clay became a natural way for people to illustrate what they wished others to see. A free surface was usually available and even erasable. However, such surfaces had some drawbacks. Only a few people could see a scratched-out image before the wind erased it or a mastodon stepped on it, and if it was something you wanted to save, you could never pick it up and display it. The solution was obvious: to scratch and paint images on cave walls. This very permanent art form has definitely stood the test of time, but it, too, faced problems. Proper lighting wouldn't come about for thousands of years, and you couldn't take your art with you to new digs, not to mention the unforgiving nature of scratching on a rock wall. Eventually, ingenuity overcame such obstacles and produced images on things you could carry with you such as clay pottery, pieces of ivory, bone, wood, and even metal.

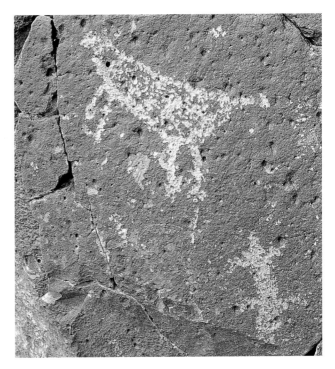

This petroglyph was scratched and chipped on a rock surface in the San Luis Valley of Southern Colorado. It was probably made with a sharp, hard rock like obsidian by an artist who lived about ten thousand years ago. (Photo by Vince Spero)

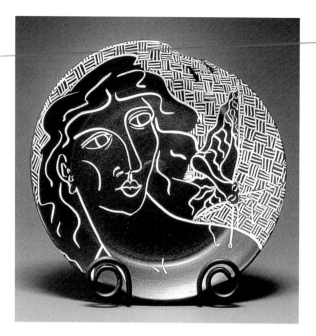

EARLY METHODS ENDURE AND DEVELOP

These innovative solutions are still in use today after thousands of years. Ceramists still do sgrafitto on unfired clay vessels or sculpture by scratching through a colored slip to expose the clay beneath. Scrimshaw artists still use sharp instruments to scratch

MIA TYSON *Fleeting Moments*
Porcelain plate, sgrafitto on ceramic.
Mia describes her sgrafitto technique for this beautiful porcelain plate as "slab, throw, and distort." She applies a slip to the surface, carves it away to expose the white porcelain clay beneath, then fires the piece, giving it a handsome sheen.

TOM HIGH. *Scrimshaw Art*
Scratched on ancient cave-bear teeth, Tom's scrimshaw art is another form of expression whose beginnings go back to prehistoric times. American whalers of the eighteenth and nineteenth centuries developed it into a popular art form during their long sojourns at sea. They scratched out images on whale bones and teeth with sailmaker's needles, then rubbed the soot from whale-oil lamps into the scratches.

DANIEL BURLISON *Raven Steals the Sun*
Sterling silver engraved bracelet
Dan's strong engraving was inspired by tribal designs indigenous to the northwest coast of the United States. While engraving is an ancient art, it was actually fairly late in the history of this art that the engraved metal printmaking plate was developed for producing multiple images on paper.

STEPHEN QUILLER *Le Mouton*
Drypoint on copper plate,
2¼ x 3¼" (5 x 8 cm).
Steve used drypoint lines as well as aquatint techniques for the grays in this image. He scratched with a sharp needle tool, creating fine metal burrs along the sides of each scratch. When the plate is inked and wiped, the small burrs hold most of the ink that is transferred to the print paper. These burrs give the lines a soft-edged look.

out images on ivory or bone, then fill the scratches with carbon black and tallow or other more modern pigments. Metal engraving is still used to decorate numerous items of copper, bronze, iron, and steel. Printmakers also scratch, etch, and engrave into metal plates today for drypoint prints, etching, and engraving. And, of course, wood items have long been decorated with scratching, carving, and painting. In Japan, carving into wood for decoration later developed into the woodblock print, which produced, for the first time, multiple images of the same piece of artwork by applying ink to uncut areas of the woodblock plate and transferring that ink to a piece of paper.

This innovation was later joined with Gutenberg's press to produce books with woodblock illustrations. With the advent of photography and offset lithography, illustrations could be photographed and converted into plates that ran on lithography presses. Black-and-white artwork with no grays, similar to woodblock images, were easier to reproduce. Those with fine grays, such as wash drawings or photos, were converted into halftone printing plates, a two-step process that produces the dot pattern seen most easily in today's newspaper photographs.

CHARLES EWING *La Isla Church*
Pen and ink on clay, 7 x 5" (18 x 13 cm).
Some of these branches were scratched out after background lines were inked in. Inked lines on the water-insoluble clay surface dry to the touch within seconds, and from that point on, they are almost smudge-proof. Those same lines, however, can be dimmed or removed with steel wool. Notice how I dimmed lines around the perimeter to direct focus toward the church steeple.

INVENTION AND EVOLUTION

As innovations continued to evolve, the next important contribution was made by an Austrian inventor, Karl Angerer, who developed the first scratchboard in 1864 by applying a layer of chalk on a cardboard substrate, then painting that with black ink. Scraping off the ink to expose white clay beneath created an image of pure black and white with very crisp edges similar to a woodblock print, and these new scratch-board illustrations reproduced well on commercial presses of the day. Furthermore, since the artist was *scratching* white lines into the clay surface rather than *carving* into a block of wood, the control over the rendering was much greater. Artist-illustrators have perfected this technique over the years, creating a continued appreciation and demand for this highly skilled talent.

HIROTOSHI MAEDA *Murakami House*
12 x 16" (31 x 40 cm). Private collection.
*Hirotoshi's scratchboard work exhibits the meticulous control consistent
with the most accomplished illustrators using this medium.*

Diverse Applications

Scratchboard renderings still play a key role in the world of commercial illustration. Its uniqueness as an art form that allows both the application and removal of pigment from a chalky surface, plus a variety of unusual techniques to facilitate detailed rendering, has fascinated artists and art appreciators since its invention.

It was only a matter of time before many artists other than illustrators began

DOUGLAS SMITH *Hornblower and Hotspur*
15 x 10" (38 x 25 cm). Collection of the artist.
This piece on Essdee Scratchboard, one of a series on Horatio Hornblower, is a classic
example of excellence in design and execution in scratchboard illustration.

experimenting with the artistic possibilities of the clay surface. Free from the limitations imposed by the commercial printer's preference for more economical black-and-white line art, this surface could now be approached with fine-art techniques incorporating the subtle gray values of graphite and ink washes, plus applications of a wide variety of color mediums.

But with more experimentation, artists began to discover problems using scratchboard with certain pigment mediums, and its limitations particularly where perma-

nence was concerned, an important consideration for fine artists. After all, the scratchboard in use during most of the twentieth century was developed primarily for illustration purposes, not for long-term display, exposing work to periodic cleaning, standing up under potential mishaps in handling, air-moisture fluctuations, and so on. What's more, clay-surfaced panels were only available in relatively small sizes that suited the illustrator's needs but not the needs of artists creating large-scale works for public display. So by the 1970s, artists

SALLY MAXWELL *African Zebra*
12 x 12" (31 x 31 cm).
Sally used a scratching nib for the zebra and African tribal patterns to imitate the woodcut technique, enhanced with colored inks.

CHARLES EWING *Flowers Young and Old*
28 x 22" (71 x 56 cm).
This piece was composed in my studio from Mexican figures photographed separately. Sketching directly on the white-clay surface with a #6 graphite stick, I could easily change positions of the individual figures by erasing with fine steel wool and redrawing. When satisfied with my composition, I cleaned up the drawing and began applying acrylic inks, scratching or abrading the inks and applying more.

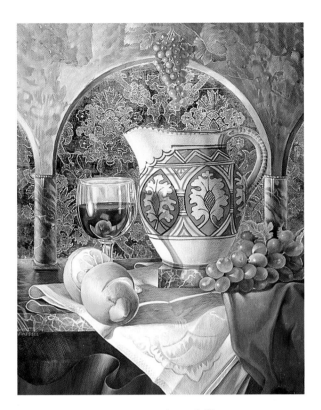

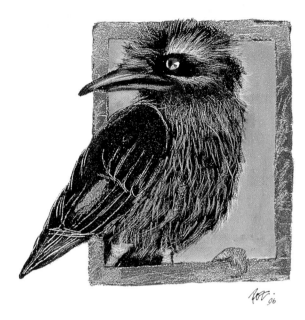

FRED WESSEL *Vino della Casa*
15 x 12" (38 x 31 cm).
The hardboard-backed clay surface is ideal for mixed-media works such as this one in egg tempera and gold leaf. Egg tempera, in particular, requires this kind of rigid, absorbent, reflective surface for the buildup of translucent layers of paint.

ROSLYN STENDAHL *Raven*
10 x 8" (25 x 20 cm).
Roslyn has found that acrylic inks seem to float more on Claybord Textured and dry a more brilliant color than they do on watercolor paper or illustration board, which she regards as a definite plus. Gold leaf adds luster.

increasingly felt the need for a more versatile clay surface with expanded possibilities in the arena of fine art. No one felt that need more than I, who had come to love scratchboard drawing but was less than enchanted with the surface's other limitations. In 1973, I began experimenting with clay formulations applied directly to a Masonite panel, a clay surface I used successfully for eighteen years. It solved many of the problems described above, opening up the choice for more techniques and pigment mediums. This innovation led to the commercial manufacture of the brand known as Claybord— a line of clay-surfaced panels that are

discussed and shown throughout this book.

Now, artists have a choice of several clay surfaces to fit the needs of their artwork, be it for illustration, fine art, or both, for there is very little that distinguishes fine art from illustration except its intended use. Therein lies the consideration of the physical aspects of the different surfaces available today.

So, we began many thousands of years ago scratching our images on the clay of the earth, and to the clay we return, though now with a legacy of innovation at our fingertips and the excitement of discovery around every corner. Let us begin by understanding the nature of clay surfaces.

A clay art surface consists of unfired porcelain clay applied in a thin layer to a support made of cardboard or hardboard (similar to Masonite). Such a surface is both *absorbent* and *easily scratchable*—which makes it different from any other drawing or painting surface.

Images are created by applying, as well as removing, pigment. The two rendering processes are employed to varying degrees, depending upon the type of clay surface used, the choice of pigment, and the qualities aimed for in the finished piece. The variety of art techniques possible on clay surfaces is truly astounding, as you will see in these pages and discover for yourself through your own experiments.

Clay Surface Choices

Clay is found in the earth as deposits of ground particles of igneous rock that have gradually become sedimentary layers at the bottom of oceans, lakes, and riverbeds. Nature produces clay of many different colors and particle size, depending on their source. Kaolin, the family of clays used by ceramists for making porcelain, is the choice for clay art surfaces, primarily due to its whiteness, small particle size, and nonabrasiveness. However, while the clay for porcelain-ware is fired into a hard, glasslike substance, the clay on art surfaces is not fired at all. The dry clay particles are merely mixed with water and a binder and then applied to the support either by mechanically spraying or pouring the clay mixture onto the support and allowing it to dry. This dry clay surface is then either compressed between smooth rollers to give it a smoother and denser surface (Essdee Scratchboard, a brand manufactured in England), or it is sanded (Claybord), or neither sanded nor compressed (Claybord Textured).

Let us review the characteristics of these different types of clay surfaces and how each serves different artistic purposes. As with any medium, the more you know about the potential and drawbacks of your materials, the better you may use them to your particular advantage.

There are two principal types of clay surfaces: those with a water-soluble clay binder and a cardboard or paper support; and those with water-insoluble clay binders and a hardboard support. Generally, both types accept and hold many types of pigment. The differences lie in the versatility of art techniques possible on each, and the intended purpose of the artwork.

Cardboard Support, Water-Soluble Clay Binder

Made by spraying the clay mixture on the support then pressing it between steel rollers, this type has a very smooth surface. Water-soluble protein-based binders are used to hold the clay together as well as to the support. The thinner of these boards are excellent for reproduction, being able to bend around the rollers of modern digital scanning machines. These boards may also be cut to size easily with a matt knife.

In terms of uses, this type support works very well for illustration techniques and for display as fine art, if the thin cardboard support is properly mounted and protected. Water-based mediums such as inks and watercolor may be used on it, but

with more caution against getting the surface too wet or working it while wet. In addition, clay with a water-soluble binder on cardboard is a bit softer than water-insoluble clay on hardboard, allowing for an easier scratching stroke.

Examples of this type are Canson Scratchboard, Paris Scratchboard, and Essdee Scratchboard. (Manufacturer/distributor information for these and other brands discussed will be found in "Resources for Materials" at the back of the book.)

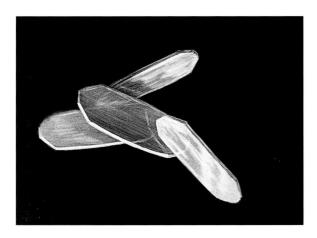

These are individual clay particles—26,000 times actual size. The flat, elongated crystals gives the clay surface excellent reflectivity, an ideal quality for an art surface to be able to show off transparent color at its most brilliant.

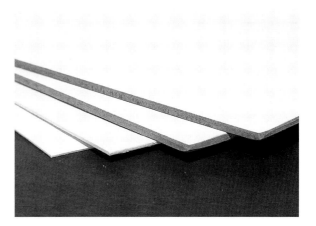

From top to bottom, the two hardboard support, water-insoluble panels are Claybord Textured, and Claybord; the two cardboard support, water-soluble panels are Paris Scratchboard and Essdee Scratchboard. The difference in thickness of the two types of boards can easily be seen.

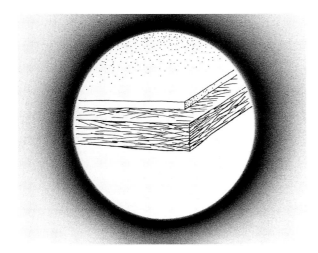

This illustration shows the layering of water-soluble clay on top of a cardboard support.

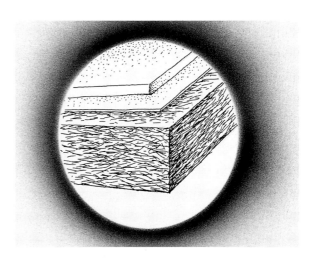

Layering of water-insoluble clay on a hardboard support; the sealing layer in between inhibits the passage of wood acids into the clay layer.

Hardboard Support, Water-Insoluble Clay Binder

This type offers more versatility in the use of different mediums, particularly those that are water-based, since clay surfaces on hardboard supports can be soaked with water and dried repeatedly, and even vigorously worked while wet. Well suited for display with the clay surface already permanently mounted to a hardboard substrate, this support requires no protective glass if the artwork is sealed with varnish.

There are four kinds of hardboard support made by Ampersand, all manufactured with a porcelain-clay scratching surface applied directly to an eighth-inch acrylic-sealed hardboard support. All have a pH-neutral surface, approximately 0.012"

thick with water-insoluble binders in the clay. All can be varnished and displayed without glass.

- Claybord Original—also referred to as Claybord White or simply as Claybord— is a smooth, white-clay surface ready for application of a range of mediums that are dry, water-based, or oil-based. The surface has a lightly sanded tooth, or texture, created with a random-orbital pattern sander. Workable with scratching or abrading tools even while damp, this surface is used for traditional scratchboard drawing techniques with ink as well as with the other mediums named.

CHARLES EWING *Mystery of Innocence*
16 x 24" (41 x 61 cm).
Claybord is also used as a surface for monoprints (detailed in Chapter 6). This offset lithograph is from an edition of 150. With subtle India ink washes and additional details scratched into every individual print, each looks like an original.

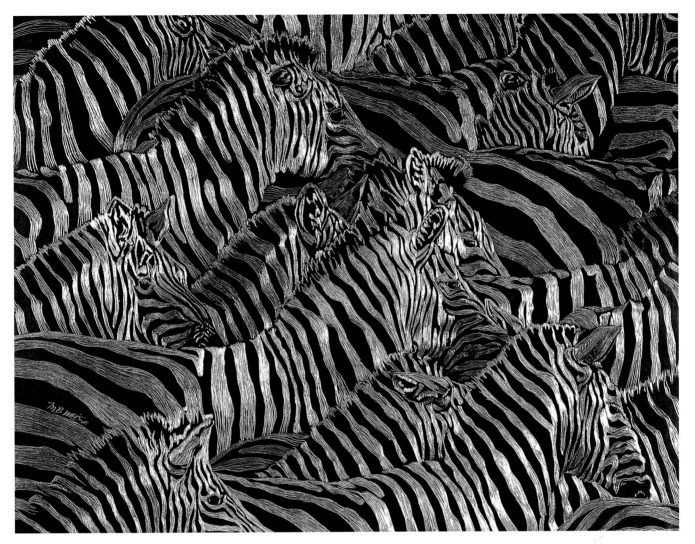

- Claybord Black has the same surface as Original, but with a thin coat of water-proof India ink. Pure India ink, ink washes, or colored paint mediums can be applied over scratched areas. It is also workable while damp.

- Claybord Textured (also referred to generically as textured clay surface) is surfaced mainly with porcelain clay, has a pebble texture, and offers a high degree of absorbency close to that of watercolor paper. Scratchable, though less capable of very fine detail work, it is an excellent surface for water-based pigments, giving smooth washes as well as accepting impasto applications of acrylic or gouache. This is also a very interesting and versatile surface for oils.

- Clay Mixture, available by request from the manufacturer, comes in containers so artists may apply it to smooth clay surfaces in a texture.

WORKING ON A CLAY SURFACE

Distinguished among art surfaces, the clay surface exhibits a unique combination of characteristics that puts it in a class by itself.

Versatility: The dry clay surface readily accepts graphite pencil, colored pencil, watercolor pencil and crayon, ink, tube watercolor, acrylic, gouache, casein, egg tempera, encaustics, oils, water-based oils, oil bars, and oil-based printing inks. Of course, the scratching and pigment-removal characteristics are unique for each medium.

Absorbency: Dry clay is extremely absorbent, readily taking on a lot of water for a given amount of clay. The small amount of binder that holds clay particles together and also binds the clay layer to its substrate reduces this absorbency only slightly. The clay particles form a lattice that acts like a filter when wet pigment is applied to it. Pigment remaining on the surface may be gently or brusquely scratched or scraped off, thus reexposing the white clay, which is the basis of the scratchboard technique. Because the paint or ink binders saturate the clay, they hold the pigment tightly to the surface.

Chalkiness: The fine grain of the clay surface, its softness, and its moderate chalkiness allow the technique of pigment removal by scratching or abrading. The surface can also be incised more deeply than mere pigment removal for a variety of textural effects. Scrimshaw techniques can also be employed by incising lines with a sharp instrument, filling those lines with pigment, then scraping the rest of the surface clean to leave fine dark lines.

Acidity: Of growing concern to artists is that their drawing or painting surface is free of debilitating acids or strong bases (alkali). A pH-neutral surface has very little of either, meaning that pigment or the pigment's vehicle and binder painted onto such a surface won't be chemically altered over time by acidic or basic chemical interaction, sometimes capable of changing the pigment color or affecting the strength of its binder. Clay is chemically inert over a large pH range, providing an excellent surface in this respect.

Tooth: The roughness of art surfaces varies greatly, from the coarsest oil-painting linen to the smoothest of hot-pressed papers. Prepared clay surfaces are generally smooth unless they have been impressed with a stipple or fabric-weave effect produced by textured rollers (Scratch-Art clay surfaces), sanded (Claybord Original and Black), or specially prepared for a random pebble texture (Claybord Textured). The clay itself has a fine tooth and no depth of fiber, but it will "pull off" (abrade) dry media such as graphite and colored pencil to create a mark, though not as well as paper will. However, watercolor pencils and crayons, being softer, work very well on clay. A sanded clay surface improves the "pull off" of dry mediums. On the other hand, a smooth surface does allow very fine, sensitive work whether with pencil, pen, or brush.

Reflectivity: Particularly when part of a drawing or painting surface is exposed in the finished piece, its ability to reflect light through a transparent or translucent layer of pigment is important to the brilliance of

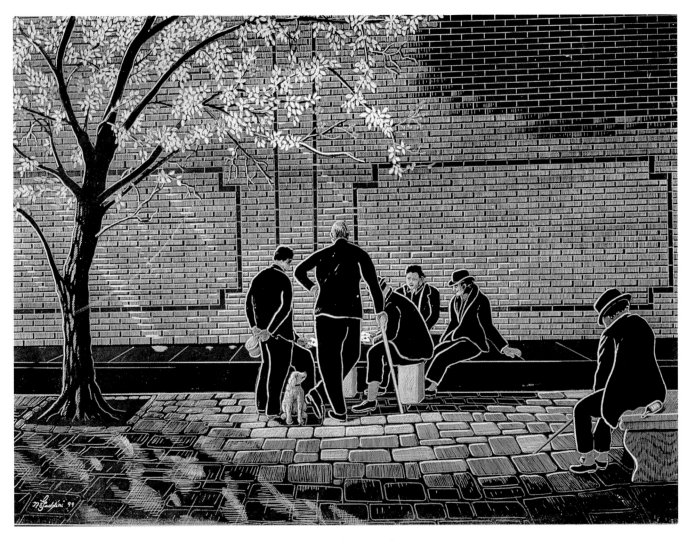

NORMAN GADDINI *The Card Game, Boston*
18 x 24" (46 x 61 cm).
*Norman has achieved a combination of artistic stylization and human street-side
warmth with this black Essdee Scratchboard drawing colored with watercolor.*

the color. This applies equally to transparent watercolors on paper, oils on canvas, and various pigments on clay.

As we've seen (on page 21), magnified clay particles look like shards of glass with excellent reflectivity. Therefore, thin washes of watercolor have a rich luminosity as light is reflected from the clay surface through the transparent layer of paint, much as sunlight coming through stained glass gives a richer hue than the same glass without backlighting.

Lightfastness: Clay surfaces are composed of inert mineral particles that do not react with ultraviolet rays as do organic cotton and wood fibers found in papers and canvas. Therefore, the inorganic surface does not yellow or deteriorate even in long-term, direct exposure to the sun. Of course, pigments applied to clay may or may not be as resistant to ultraviolet degradation, so be aware of which colors made by a particular manufacturer are fugitive. (See "Suggested Reading" for a fine book about color.)

Here we see the scrimshaw technique on the right, where black ink was scraped off the surface around the filled scratch, leaving the fine scratch marks black. Also note the pile of clay dust produced from the scraping, which shows the chalkiness of the clay surface.

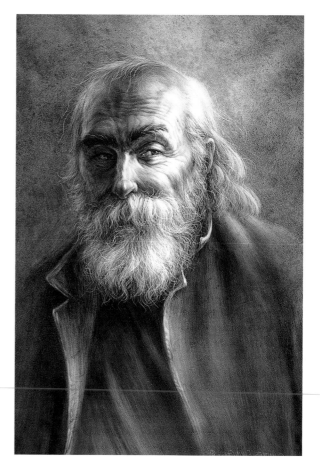

CHARLES EWING *A Little Humor*
26 x 16" (66 x 41 cm).
India Ink on the clay surface is a forgiving medium for portraits. Capturing personality is often a matter of trial and error, playing with the features until they wink back at you.

RON UKRAINETZ *Pygmy and Lodgepole*
12 x 24" (31 x 61 cm). Collection of Gary and Deanna Palm.
*Note how beautifully the softness of Ron's airbrushed background
allows the harder-edged foreground to come closer to the viewer in
this handsome acrylic work on black scratchboard.*

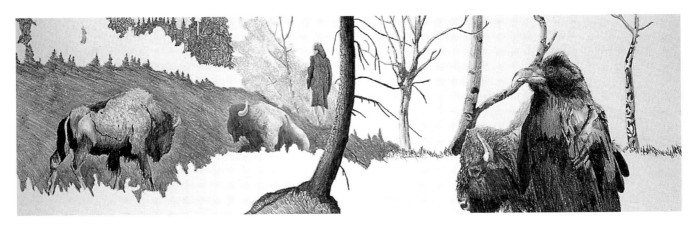

LARRY BASKY *The Guardians*
8 x 26" (20 x 66 cm). Collection of Bud and Terre Johnson.
*In this captivating piece, along with Larry's soft graphite rendering, there is a subtle technique—
barely discernible except when viewing the original at the right angle for light to bring it out—
where an area of grass is rendered with nothing more than rather deep scratches in the white
clay, giving a physically textured area to an otherwise smooth surface.*

BINDERS FOR CLAY PARTICLES

A binder is used to hold the clay particles together and to adhere the clay layer to its support. Using too much binder reduces absorbency and hardens the surface, whereas too little makes the surface too fragile, particularly when wet. As noted earlier, two general types of binder are used: water-soluble and water-insoluble. Let us explore their qualities a little further.

Cardboard or paper-backed scratch-boards use water-soluble binders. These surfaces accept water-based mediums well, and may be delicately rendered with scratching techniques, but care must be taken not to get the surface too wet, as the clay binders may lose their integrity, softening the layer of clay. The surface should be allowed to dry before attempting any scratching techniques.

Hardboard-supported clay surfaces use water-insoluble clay binders. The absorbency of the clay and delicacy of scratching its surface are comparable to the water-soluble surfaces. However, a thorough wetting of the clay surface only slightly softens it without destroying the bond which, when dry, assumes its original integrity. This is similar to the way wood softens when moistened, then dries good as new. This quality allows artists to use ink or watercolor washes over and over again, scratching between applications or *even while the surface is still damp,* without compromising the integrity of the surface.

This illustration shows two types of physical texturing that may be done with any of the clay surfaces. The surface on the bottom was cross-sanded in two directions with 80-grit sandpaper. On the top, Ampersand's Clay Mixture was added to the surface with obvious brushmarks, plus a pebbly texture applied with a sponge. India ink was solidly painted into half of each of the textured areas; that was then scraped with a blade to show the effect of exposing the high points of the clay.

SUPPORTS FOR THE CLAY SURFACE

The support of an art surface is there to physically support the rendered image for its intended purpose. If the support fails in its purpose, the artwork suffers damage. Oil painters, for example, prefer primed and stretched linen or gessoed wood panels, for these supports have been proven durable over time. With scratchboard creations, the marriage of clay and pigments is deserving of the proper support for the intended lifespan of the artwork.

If the purpose is to create an illustration for commercial reproduction, the permanency of the support is not a large issue. However, if an artist wants to display work for an extended period of time, the durability of the support assumes greater importance. Even within an artist's lifetime, imagine the abuse a piece of art can suffer being dropped, bumped, splattered, smeared with dirty fingers, framed and reframed, hung in direct sunlight, and

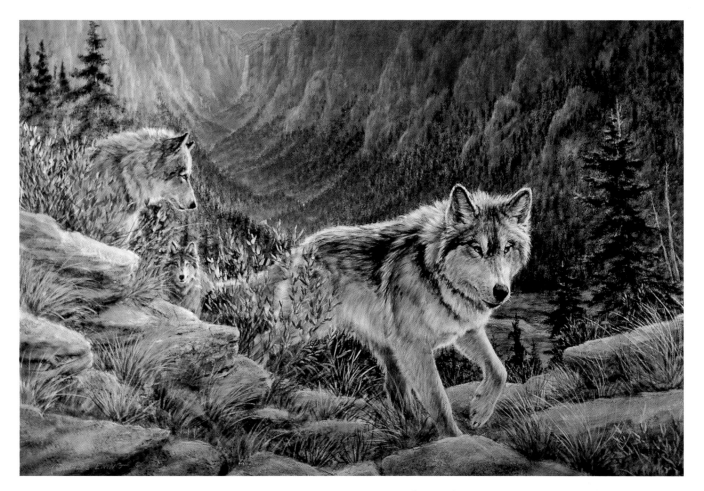

CHARLES EWING *Topping the Ridge*
24 x 36" (61 x 92 cm).
*Alternating acrylic ink washes and scratching techniques gave me control over detail,
texture, depth, and light. Values are darkened in certain areas with rich overlays of color,
but highlights can be regained by scratching through the wash to expose the white clay.*

stuffed in a closet with ice skates! What a shame if the art world of a few centuries hence were to deem that work a masterpiece, yet it had been damaged beyond repair.

Cardboard or paper-backed supports serve the illustrator's purposes extremely well. They are relatively inexpensive, may be easily cut to size with a matt knife, accept wet mediums (if not overworked), are nonyellowing, and some may even be fed into digital image scanners that bend artwork around a roller. The clay layer in these products is very permanent if protected from moisture and physical abuse, but their supports are relatively fragile, subject to bending and folding (cracking the clay), to water damage (water-soluble binder), and to easy punctures and scratches. To preserve and display a piece created on these products, it is wise to provide another more substantial backing such as hardboard or a thick, rigid cardboard with the scratchboard glued permanently to

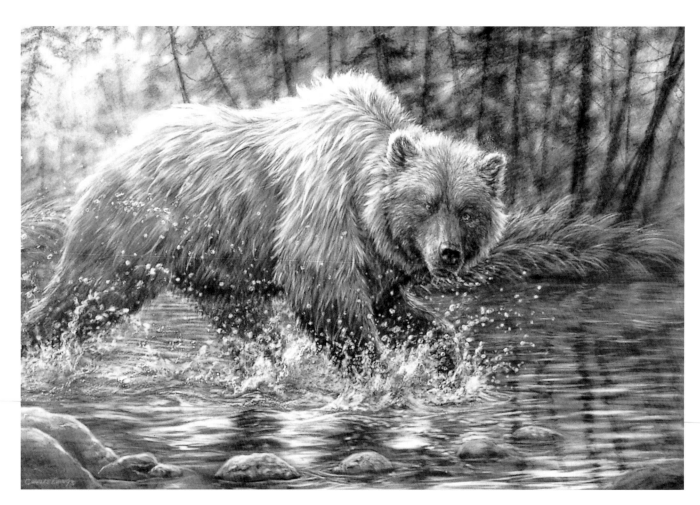

CHARLES EWING *Great Bear*
24 x 36" (61 x 92 cm). Collection of the artist.
Up until an India ink drawing on the clay surface is sealed with an acrylic varnish, changes can be made. Another bear could be placed in this composition, the forest changed to tundra, the water to a grassy park. This freedom to experiment is very valuable to the artist.

it. Heat-sensitive adhesive film (used to mount photos) bonds scratchboard to a smooth hardboard support, preferably before the artwork is done. Beware of contact cements such as spray glues, as they can lose adhesion if the work is ever placed in sunlight. Bubbles can occur that cannot be smoothed nor can the rest of the scratchboard be pulled up for re-gluing. This was precisely the reason I started looking for a better scratchboard surface. Furthermore, even if such work is sealed with varnish, it should be framed under glass to protect it from moisture damage and inadvertent abuse.

Again, note that hardboard-based products offer a clay layer bound directly to rigid, sealed hardboard. Indeed, a finished piece may be varnished with a clear acrylic spray and popped into a frame without requiring glass protection. The drawing or painting surface, thus sealed, may be safely cleaned with a damp cloth. I have prepared my work for presentation in this manner for eighteen years, a process that is detailed in a later chapter.

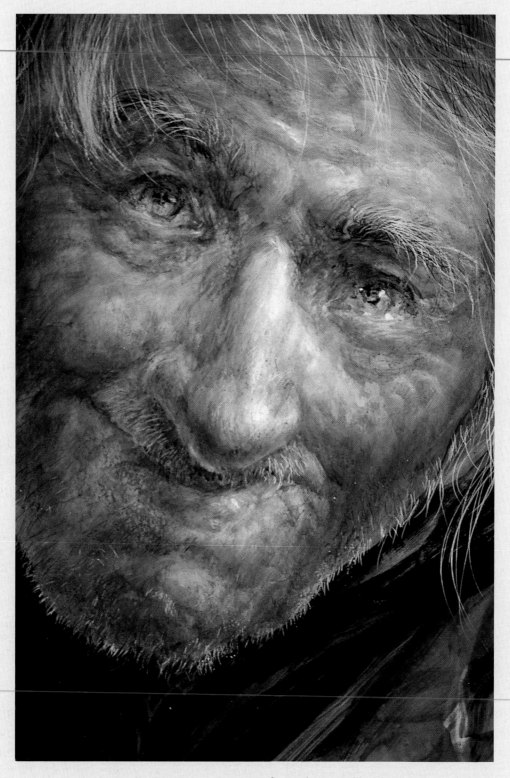

CHARLES EWING *Eyes of Kindness (detail)*
16 x 12" (41 x 31 cm).

This character, entirely made up, was created by alternating acrylic ink application with scratching techniques. If I were to continue working this piece, zeroing in on every wrinkle and freckle with absolute precision, this old guy would start looking as tired as I would feel. I probably went too far with the detail as it is! But that is, of course, a question of personal taste.

EXERCISE

You may be interested in making a couple of lightfastness test panels for yourself, using either a 5-by-7-inch panel of the cardboard-backed or hardboard-backed variety.

Work with the pigment mediums with which you are most familiar, particularly those of questionable lightfastness. First, paint or apply the pigment in stripes from top to bottom of your panel surface. Allow your panel to dry thoroughly, then tape a completely opaque cover such as aluminum foil or mattboard over half of the board so that half of the pigment stripes are covered and half are exposed.

Place your work in a south-facing window where it will receive a good dose of sunlight along with ultraviolet rays every day for several months. Check it periodically to see if the pigments have faded or if the clay surfaces themselves have yellowed or changed in any way.

There is nothing like proving something for yourself, as opposed to taking someone else's word for it!

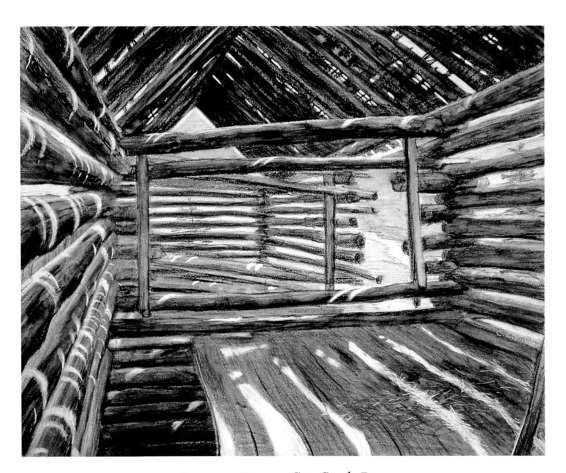

CHARLES EWING *Cat Creek Barn*
8 x 10" (20 x 25 cm). Collection of the artist.
Watercolor pencils have two advantages over wax-based colored pencils when used on the clay surface: They give a mark of darker intensity, if desired, and they can be dissolved and blended on the clay surface with a wet brush. Of course, using colored pencils on clay allows the artist to scrape the pigment off for a highlight or to clean an edge, as I have done in between the logs of this old barn.

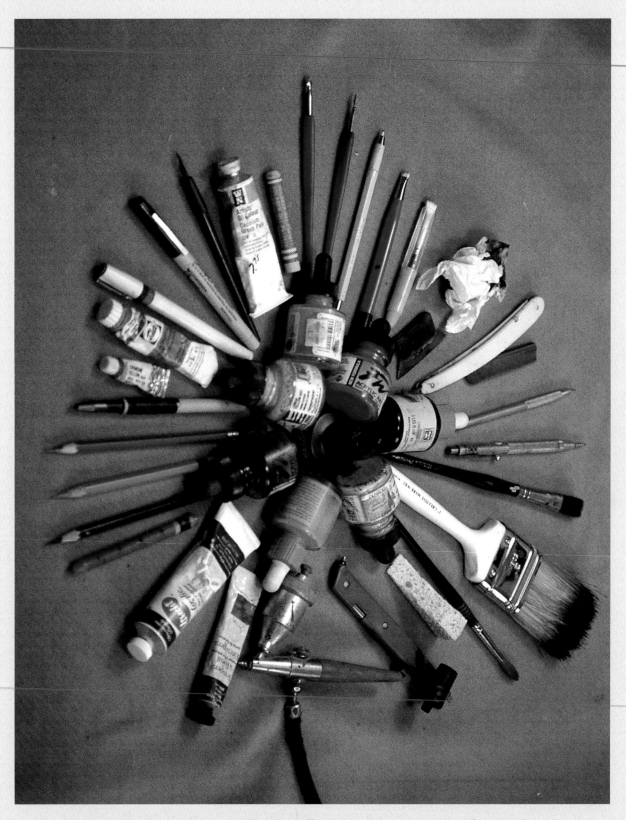

Perhaps there is no other art surface that effectively uses such a variety of materials and techniques as the clay surface, encompassing a wide range of pigment mediums and pigment application tools—such as brushes, sponges, and paper towels—and pigment-removal tools—such as scrapers, needles, nibs, and found objects of all kinds.

2 | *Tools and Pigment Mediums for the Clay Surface*

IN SCRATCHBOARD ART, pigments are manipulated on a clay surface by nibs, brushes, and other tools guided by the artist's hand and observed by a pair of eyes connected to a brain that gives a few orders to the hand, but mostly sits back and enjoys the results of this fascinating combination of purpose and accident we call art! Tools can be anything that helps the artist manipulate pigments into an image that brings a smile. Pigments can be almost anything from mud to pea soup, but preferably are composed of lightfast materials of good bonding strength that will neither fade nor fall off the painting surface for the expected lifespan of the artwork.

This chapter presents the broad range of such materials available to scratchboard artists. Under "Resources for Materials" you will find contact information for suppliers of products discussed here and in other chapters.

But drawing and painting tools for the clay surface include not only the physical brushes and scratching instruments that will be described later in this chapter; they also include the qualities of a two-dimensional image that help produce illusions of reality, whether these interpretations are superrealistic, impressionistic, abstract, or a combination of styles. I call these qualities our "tools of artistic vocabulary," essential to communicating the content of an image to the viewer of our artwork. So, let's review this vocabulary in preparation for communicating our visual imagery on a clay surface.

TOOLS OF ARTISTIC VOCABULARY

Composition is our first vocabulary tool, an interesting and appropriate arrangement of shapes and line to carry the feeling of the subject—be it tranquility, excitement, motion, solidity, or limited focus.

Line defines the contours of objects or shapes in the composition. But these objects and shapes do not exist alone within a composition; they are all connected as part of a whole. Thus, as the viewer's eye passes from one shape to another within the scene, its path describes a continuity of line, usually the path of least resistance—and most reward. Being aware of how the eye can be guided gives you, the artist, a tool that can be used to guide viewers' eyes to the reward you intended for them.

For example, in portraying an animal in motion, the subject is a finely tuned machine of muscle and bone with all its parts moving in concert with balance, efficiency and, above all, with the intent to move. Drawing an animal in such a pose requires depicting anatomical correctness of the body with indications of muscle, bone, hair, and facial expression. But to achieve a sense of motion through a landscape, an awareness of the continuity of line from the animal into its environment is essential.

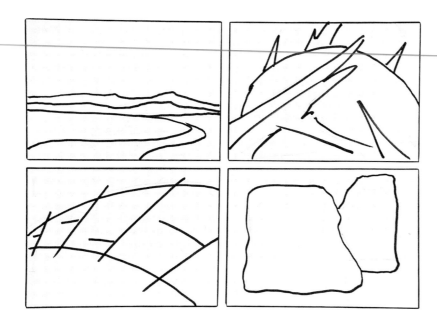

Compositions with different messages: upper left, tranquility; upper right, excitement; lower left, movement; lower right, solidity.

Lines in the background can be placed to establish a rhythm suggestive of the animal's moving legs and undulating torso, making the animal part of the landscape.

Mass indicates the physical substance of an object by giving it three-dimensional volume, solidity, and a visual sense of its weight. It is defined by light and dark values within the perimeter of its form.

Value defines the qualities of lightness or darkness relative to each other, expressing contrast in all its subtleties. Given a light source, value defines form and mass of objects by indicating how light strikes them, illuminating surfaces exposed to the source of light and creating shadows of varying intensities on the surfaces not reached by light. Value also contributes to creating a feeling of spatial closeness or distance as the contrast of light and dark value diminishes from a foreground of harsh contrast to a background of lesser contrast. It influences the focus of a piece, as our eye is naturally attracted to areas of high contrast and tends to pass by areas of low contrast.

In the world around us, we perceive the content of what's before us largely through our eye's interpretation of light and dark values. A black-and-white world devoid of color would still offer enough content to experience reality. In fact, the absence of color eliminates a major distraction from experiencing the drama of value. A black-and-white or monochromatic image is a simplification, a distillation of the real world that separates out tonal values for us to experience the impact of unadorned form.

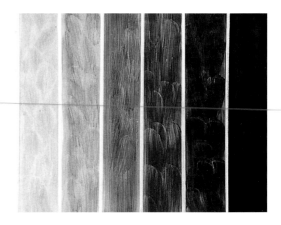

Value sequence, left to right: white, light, mid-light, mid-gray, mid-dark, dark, black. This was done using a sable brush and India ink, applied fairly dry, one way of achieving a range of value.

CHARLES EWING
Easy Grace
20 x 30" (51 x 76 cm).
Collection of Glenn and
Mary Swan.
This piece was inspired by watching a herd of bull elk cross the road in front of us, jumping two fences at full gallop. It was the impressive rhythmical quality of that experience that I attempted to recreate on Claybord. Their bodies were an undulating muscular wave as they sailed gracefully over the fences.

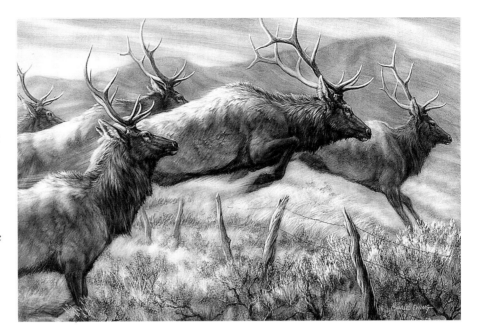

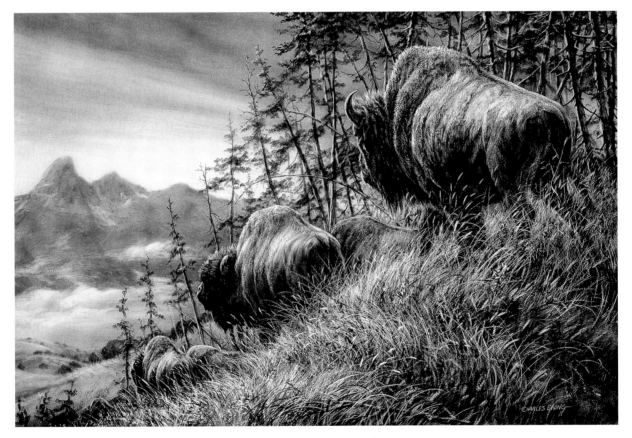

CHARLES EWING *Massiveness in Motion*
24 x 36" (61 x 92 cm).
The inked Claybord surface of this piece was sealed with an acrylic varnish and framed without glass, giving viewers a more intimate appraisal and appreciation of the art. The surface thus sealed may even be washed with a damp, soft cloth and mild detergent.

Edges of all the forms we see are not all perceived simultaneously as crisp and sharp. When we focus our attention on one part of a form, those edges are sharp, whereas within our peripheral vision of the rest of the subject, the edges are blurred, sometimes being totally lost against a background of similar value. As with an area of highly contrasting values, the eye is naturally drawn to sharp, crisp edges in an image. The artist can thus choose to manipulate the focus of the piece, guiding the viewer's eye to an important focal point by giving those forms sharp edges and allow-

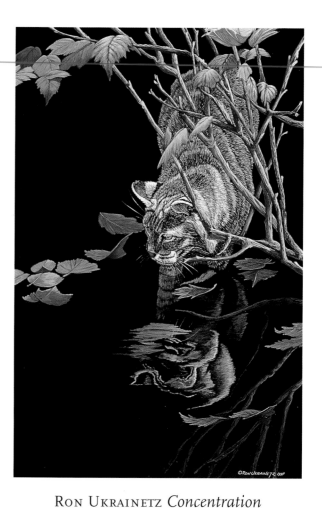

RON UKRAINETZ *Concentration*
18 x 12" (46 x 31 cm). Collection of Robert and Bonnie Wasson.
Ron's beautiful composition is enhanced by a high contrast of the subject with its black-ink background. Note those interesting shapes in the black negative spaces—areas between and around the subject—elements as important to the composition as the cat itself. Also note how reflections of a slightly lower value add compositional shapes but do not compete with the main subject.

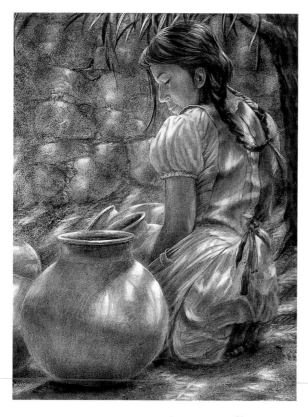

CHARLES EWING *Niña con Ollas*
(Little Girl with Pots)
24 x 20" (61 x 101 cm). Collection of the artist.
Dappled light falling on a figure can be so beautiful, and it can be done quite easily using a clay surface. This piece was rendered almost entirely in dark and mid-value grays before I used a small pad of steel wool and a fiberglass brush to create patches of light.

ing less important areas to appear as peripheral vision by blurring those edges. This device enhances the viewer's illusion of witnessing the scene in a natural way, as the relative sharpness of edges also influences the illusion of distance, since the edges of foreground objects, being sharper, appear nearer in space than those of the background.

Texture and paint quality can range from very smooth to very rough. The illusion of reality can be achieved by varying the *visual* texture of surfaces in the subject. *Physical* texturing of the clay surface by sanding or addition of more clay is another alternative and can add a paint-quality effect as well, particularly when texturing strokes correspond to patterns on the object being rendered. Variations become evident when each brushstroke in a piece can be singled out and identified according to paint thickness, edge sharpness, and direction.

Color is the icing on the cake. It is delicious to the eye in its tremendous range of hues and intensities.

But color is subject to its own rules of value, relative neutrality, or brilliance, and in color temperature, ranging from cool to warm in its application to subjects around us in the natural world.

One of the best approaches I have found to understanding color from a logical, common-sense standpoint is contained in Steve Quiller's excellent book *Color Choices* (see "Suggested Reading," page 141).

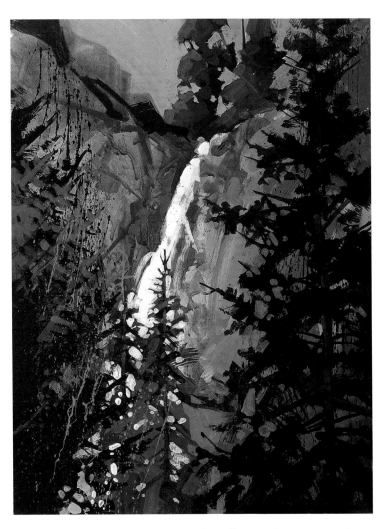

STEPHEN QUILLER *Second Falls at Phoenix Park*
16 x 12" (41 x 31 cm). Collection of Peggy and Tristan Wilson.
Steve used no scratching techniques at all on this piece. He simply likes the way the absorbent clay surface "pulls the acrylic paint off the brush."

Drawing tools are like pet dogs. If you don't spend time with them, they won't learn any tricks!

Two types of tools are used to create an image on a clay surface: pigment application tools and pigment removal tools. Depending upon the kind of clay surface chosen and the nature of the image, tools of each type may be used to varying degrees. For example,

This comparison of marks made by a soft graphite pencil, a graphite stick, and a black watercolor pencil shows the relative intensity of black achieved with each.

Jeanette Martone *Wingless Angel*
12 x 9" (31 x 23 cm).
The use of gentle values contributes an aura of tranquility to this graceful figure. Artists working with graphite pencil on the clay surface find that smudges rarely occur, even if their hands accidently smear the panel. But if smudges do occur, they can be cleaned off easily with fine steel wool.

with a black, preinked clay surface, you may choose primarily pigment-removal tools to scratch or abrade the inked surface, creating an image of white lines and areas. Then with a brush dipped in pure black ink, you might reink certain areas to make corrections. With another type surface, pretextured clay, the principal tools might be sable brushes for rendering a transparent watercolor, with only limited use of scratching tools to bring out sharp highlights. On white clay, another available surface, you might employ both types of tools throughout the execution of the piece—applying and removing pigment at every stage of the process. Each of these methods will be detailed in subsequent chapters.

Mediums

Since the clay surface is unique in accepting numerous types of pigment mediums, I encourage you to experiment with as many as possible to familiarize yourself with the qualities and potential of each for your work.

Graphite pencils and sticks of various grades may be used. Clay surfaces are generally fairly smooth (Claybord Textured is the exception) without a lot of tooth (surface roughness) that helps to abrade the graphite off of the pencil or stick. Therefore, harder leads, from 2B up to the "H" category of hardness, will not pull off as do softer leads such as 4B, 6B, and 9B. Softer grades, depositing more graphite with lighter pressure, result in lines of darker intensity without digging into the clay surface itself.

I often use a 6B graphite pencil on an 8-by-10-inch panel to experiment with thumbnail sketches for a piece, erasing with fine steel wool multiple times as I play with compositional ideas. When the thumbnail looks promising, I'll go to the appropriately sized panel and recreate the sketch, using the same pencil or a 6B graphite stick placed in a long holder to keep my drawing loose. With subjects of simpler content, I'll skip the thumbnail and sketch directly on the large panel, and with some pieces, the whole work will be executed, from start to finish, in graphite.

Charcoal, pastel, and Conté sticks are dry mediums that have limited application on smooth clay surfaces because they lack enough tooth to hold loose particles of pigment. However, charcoal and softer pastel sticks work well on a textured clay surface, the commercially prepared (Claybord Textured), or a clay-coated panel that the artist roughs up with 120-grit sandpaper.

Colored pencils that are water-soluble work extremely well on clay, laying down a line of rich intensity. Wax-based colored pencils are somewhat harder, producing a line of somewhat lighter intensity. Of course, water-soluble pencils have the added advantage

MAGGIE TOOLE *Eating*
18 x 12" (46 x 31 cm).
Maggie used her unique drawing technique, "circulism," to create this image. With her pencils, she layers color over color with a circular movement, increasing or decreasing the size of the circles depending upon the detail required. Through a happy accident, she also found that the receptiveness of clay to her wax-based colored pencils was greatly enhanced by applying a few layers of toned acrylic wash to the surface before drawing.

of being made into a wash with the application of a moist brushstroke used over the pencil line.

Ink pens—including quill nibs, technical drawing pens (Rapidograph and others), felt-tip pens and markers, and ballpoints all work well on the white-clay surface, drying quickly without bleeding and showing very

little or no smudging from your hands. Pens may be used with a variety of liquid color, including watercolor, India inks, colored inks, acrylic inks, and in printmaking, tusches. Thanks to the water-insoluble clay binder in hardboard-supported clay surfaces, you may repeatedly cross over wet ink lines, as in cross-hatching, without digging up the dissolved clay in wet areas (as sometimes happens with water-soluble clay surfaces). For extremely fine detailing with the finest penpoints, the surface may be polished to a mirrorlike finish by briskly rubbing it with a damp sponge.

When using markers, be aware of the lightfastness of the inks of various brands. Some are so fugitive when exposed to sunlight they begin fading the day they are applied. Refer to the manufacturer's specifications for lightfastness. If there are none, beware. You can perform a simple test for lightfastness by marking on a clay surface with the ink marker in question, covering half the marks with an opaque covering,

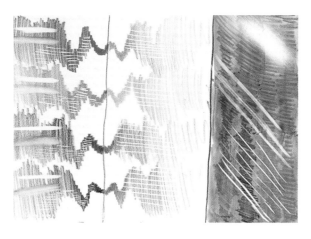

From left: Create soft highlights by lifting the watercolor pencil with a moist brush or fiberglass brush; and very soft highlights by using steel wool. And see how easy it is to scratch into colored pencil work (at right, on an acrylic wash) to create hard-edged highlights with a scraping blade.

This ink splotch was made with a paper towel wadded up, dipped in India ink wash, and flopped on the surface. Do you see a horseman in it? You may see something entirely different, which is the point of this exercise. The ability to create an image in one's mind can start with something as rough as this.

Imaginary images can be recreated very easily on a clay surface that already has most of the image in place. For this study, all I had to do was remove some ink here and add some there to bring out the figure that the ink splotch evoked for me.

This simple portrait was done with a felt-tip marker. The black pigment is easily scratched through with a scratching nib.

placing it in direct sun for days, then note the difference between the covered portion and the exposed portion. Lightfast pigment remains unchanged for years, whereas some dye-based colors show a change after two days of exposure. And some markers saturate the whole clay layer and cannot be scratched off.

Watercolors are versatile on clay surfaces. They may be used to color scratched-out drawings, to glaze over waterproof colored inks, or to paint directly on a clay surface from start to finish. Since the paint has a water-soluble gum-arabic binder, its color may be lifted from the clay surface easily with a wet brush or damp cotton swab to create a highlight or heightened value. But note that glazing over dry watercolor with a stroke of a different hue is very difficult without redissolving and lifting the bottom color. A single quick, light stroke usually works, but anything more will redissolve the bottom layer. Dry-brush approaches, on the other hand, work better.

 With the water-insoluble panel, soaking the surface is only an issue regarding the effect you want, allowing everything from dry-brush textural strokes to totally soaking the surface and puddling the color on it. In fact, a poorly executed watercolor painting may be totally sponged off the surface.

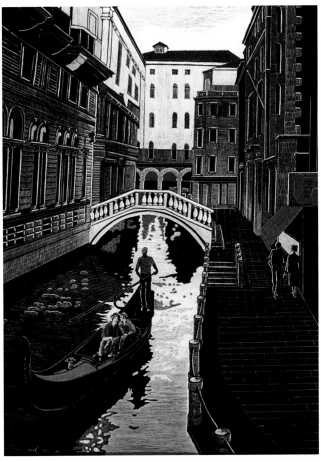

Norman Gadini *Venice*
24 x 18" (61 x 46 cm)
Norman's well-designed piece features rich opaque blacks combined with watercolors, producing interesting contrasts in this shimmering depiction of a Venetian canal.

CATHERINE DE GOLDBERG *Bird Woman*
7 x 5" (18 x 12 cm).
Catherine used watercolors and inks for this white-clay piece. She started by wetting the entire surface thoroughly, then pouring on ultramarine and burnt sienna. After moving the paint around, where the colors mixed well, it produced black, while uneven mixing resulted in tans, greens, light blues, and a purplish brown. Finally, when the inks had mostly dried, she washed some of them off in certain areas, then completed the painting by drawing into it with pen and brush and adding black, green, and metallic gold.

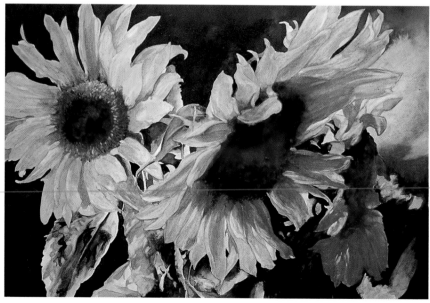

KAREN VERNON *Midnight Sun*
16 x 20" (41 x 51 cm).
Karen lifts watercolor very easily with a dried brush to vary the value and intensity of hues and to manipulate edges, giving her lush sunflowers heightened beauty. With Claybord Textured, she uses more saturated color than with watercolor papers. Color brilliance is the result.

This panel shows how acrylic color may be laid down in a wash on the smooth clay surface (red horizontal brushstrokes), scratched and abraded with scratching nibs (top) and abrasive tools (bottom), then overglazed (green vertical strokes). Of course, impasto work is also possible (at right).

Illustrating how watercolor brushstrokes react on a wet textured clay surface, note how pigment spreads with softened edges. This effect is expected with watercolors on paper, but is surprising on a clay surface. This same panel can be easily scratched into to reveal white clay beneath for highlights.

Tube acrylics, when diluted with water, work in a manner similar to colored inks, though perhaps they aren't as color intensive in dilutions. With tube acrylics you can glaze over dry washes effectively with a wash of a different color without dissolving what's already on the surface. Scratching techniques should be done early on in the paint layering before the plastic acrylic film gets too thick. However, at this stage in a piece, tube acrylics have yet a further expressive potential in the way of paint-quality variations. So far, the paint quality consists of thin applications of transparent color elaborated for detail or texture with scratching tools and reglazed with more color. Add to this juicy impasto strokes of full-bodied paint from the tube, and the result is a piece full of vitality and rich tactile interest for the viewer's eye.

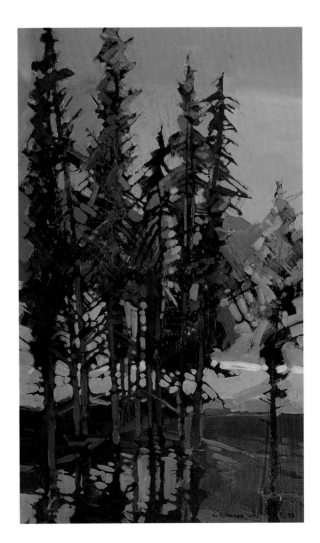

STEPHEN QUILLER *Edge of the Pond*
20 x 12" (51 x 31 cm). Collection of Edward Robran. *Claybord offers a very reflective surface for thin, transparent acrylic washes, and a rigid support for thicker impasto strokes.*

Egg tempera has many attractive qualities, one being the luminosity of the translucent paint, which in many cases is built up layer upon layer. Using the clay surface adds to this quality by providing a highly reflective surface which will project ambient light back through the translucent egg tempera, giving the paint an aura of inner luminosity.

Gouache is another versatile medium. Painted in thin, semitransparent washes, it can be easily scratched into to reveal the white clay beneath. It can be redissolved with a wet brush or sponge but holds better than watercolor, allowing some overglazing without disturbing earlier layers.

Gouache can also be painted, or even trowelled on with a palette knife in thick strokes or built up texturally for some very appealing surface effects. A variety of paint quality is possible, from thin transparent glazes to thick opaques, and the finished piece has a soft matte finish.

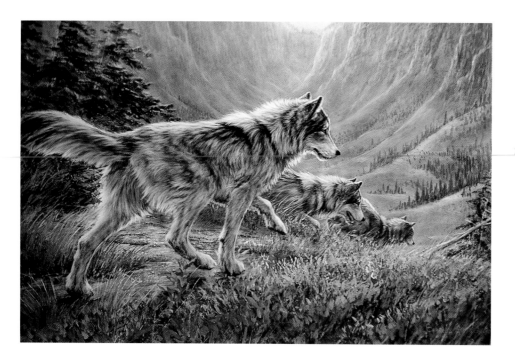

CHARLES EWING
Valley Descent
24 x 36" (61 x 92 cm).
Acrylic inks impart a rich, transparent color to this piece, but perhaps what is most unique is how this scratchboard technique can produce such finely textured fur, particularly along the wolf's back, where it is backlighted by the sun.

GARRY GILMARTIN
Charlotte
20 x 24" (51 x 61 cm).
*Garry has taken advantage
of the luminous quality of
egg tempera paint placed on
the reflective surface of
white clay to give this
appealing painting its own
source of light.*

GEORGE-ANN GOWAN *Three*
24 x 36" (61 x 92 cm).
*George-Ann physically textures a
clay-coated panel with a commer-
cial clay mixture before painting.
Her home-prepared mixture of
powdered pigments and egg yolk
produces egg tempera, which she
brushes on in alternating layers of
warm and cool colors. Her sketch
is laid in and developed with more
paint applied with brushes and
sponges; details are painted in
small strokes using fine brushes.
To give the painting's surface a
uniform sheen, she polishes it with
cotton after it has thoroughly
dried. In her continued experi-
ments with the clay surface,
George-Ann has never had trouble
with surfaces cracking or warping,
problems often experienced with
traditionally gessoed surfaces.*

Casein, derived from milk protein, is very similar to gouache in the way it works on clay, able to receive thin, transparent, scratchable washes and thicker impasto strokes. It dries more waterproof than gouache, allowing more effective layering of transparent washes, and is known for its wonderfully fresh aroma and beautiful velvety sheen when dry.

Oil paint, if not applied too thickly, can be very easily manipulated with scratching and abrasive tools for later glazes. Of course, impasto work can be done on the same panel. Because of the fragility of thin oil pigments on the smooth clay surface, a finish spray varnish is recommended. Another alternative is to take advantage of the smooth clay surface as a painting ground by sealing it with a diluted coat of pure acrylic medium before applying oil paint. Or a combination of scratching technique and oil work is possible by painting initially in thin acrylic inks, scratching out detail, form, and textures, sealing the whole surface with an acrylic medium, and finishing the painting with oils ranging from thin washes to thick impasto.

FRED WESSEL *Still Life for Bellini*
10 x 14" (25 x 36 cm).
As can be seen in this beautiful egg tempera painting, the unusual yet ancient color medium works very well on the clay surface. Much of the work is done by overlaying a multitude of small brushstrokes. The hardboard support provides the necessary rigidity for the egg tempera's permanence.

EMMA TAPLEY *Untitled*
9 x 12" (23 x 31 cm).
Collection of Remak Ramsay.
*Working with oils to create this
fascinating painting, Emma has
found that a thin application of leaf
gelatin, dissolved in warm water,
seals the absorbent Claybord surface
without losing its smoothness.*
(Photograph by James Dee.)

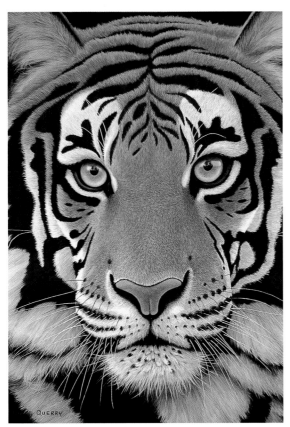

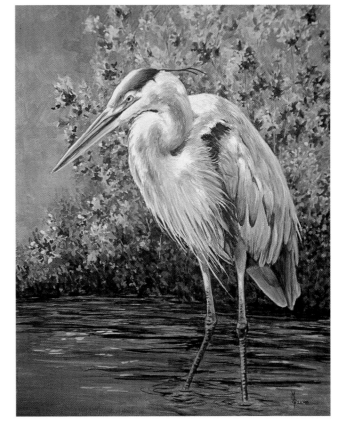

DIANE QUERRY *Beguiler*
20 x 16" (51 x 41 cm).
Collection of Mr. and Mrs. Don Smith.
*Diane has combined a richness of color and value
with beautifully controlled hair texture to make
this tiger come alive on its clay surface.*

MARILYN GRAME *Blue Heron*
11 x 14" (28 x 36 cm). Collection of the artist.
*Marilyn's beautiful work combines thin
washes to moderately thick applications of
gouache, then scratched, scraped, or abraded
to reexpose the white clay.*

Encaustics are one of the oldest painting mediums, and the hardboard-backed clay surface has proven to provide a very good support for this beeswax-based form. Dry pigment colors are mixed into melted beeswax and painted on the surface. Each successive pigment layer is fused to the one below with heat, creating a remarkably permanent image.

Mixed-media such as combinations of India ink and sumi ink work well; sumi ink is redissolvable once dried, can be lifted or pushed around on the clay surface, while India ink can be elaborated with scratching tools then painted over with gray washes. An underpainting of acrylic can be elaborated with scratching tools, then overpainted with watercolor, then manipulated with a damp brush. Or try combining transparent inks with casein or gouache to brighten and animate a painting.

ANNELL LIVINGSTON *Fragments Series*
16 x 16" (41 x 41 cm).
This encaustic work represents a unique use of the hardboard-backed clay surface. Beeswax mixed with resin is the paint vehicle and must be softened with heat to apply. Beautiful translucent impasto layers of pigmented wax can be built up. The finished painting is treated with heat so all layers fuse together.

Transparent oil washes can be applied to the clay surface, scratched into with scratching nibs, fiberglass brushes or steel wool, and even glazed over without too much mixing on the surface. Thin layers on the raw clay surface seem to dry almost immediately, though it's just the paint vehicle that is being absorbed into the clay that makes it appear that way. It works well to saturate the clay layer with a medium such as Liquin to avoid this effect.

Using gouache, this panel shows in the three horizontal squiggles transparent washes and a dry brushstroke. These are glazed over with red, with some color mixing occurring on the surface. On the right are very thick strokes. This is an excellent medium for scratch-art techniques, as the pigment dries somewhat chalky and can be delicately scratched, even in moderately thick areas, producing added interest.

SALLY MAXWELL
Red Poppy
24 x 36" (61 x 92 cm).
Sally used emery blocks of different grit to remove the black ink of the clay surface, a soft-edged technique, then airbrushed her colored inks with a few final scrapes and scratches to bring out the highlights of this intriguing floral, rendered on a large panel to magnify its forceful statement.

NORMAN BROWNE *Snake River Cutthroat*
6 x 12" (16 x 31 cm).
Norman drew this fish image with a pencil, covered it with a gray watercolor wash, then scratched out the image. Wiping off the wash, he then used acrylics, both regular and opalescent colors. After letting everything dry, he put thick beads of paint on each fish scale to add texture, then applied metallic leaf to the background, allowing some underpainting to show through. Finally, he seals his work with a clear acrylic spray.

DOLORES HERRINGSHAW
Shadows in the Afternoon
36 x 24" (92 x 61 cm).
Dolores used colored inks on a surface of white clay, lending a soft luminosity to the light in this inviting scene. The reflective quality of the clay surface adds brilliance to the transparent inks.

Application Tools

From brushes to sponges to atomizers, a wide variety of application tools works well on the clay surface.

Brushes, ranging from fine #00 sables to 6-inch so-called barn brushes, are useful. Brushwork is better on the clay surface if the brush is dried out considerably before application—the dry-brush technique. The exception to this is in the use of Claybord Textured, which has a much more absorbent surface that nicely handles a brushstroke loaded with watercolor.

Fine sable or synthetic fiber brushes in small sizes may be used for tight detail or, in larger sizes of flats and rounds, for wide strokes of evenly applied pigment.

Hog-bristle brushes when used very dry provide controlled textural applications of pigment. A small amount of pigment on a brush goes a long way on the clay surface.

Wide textural brushes normally used for house painting produce good effects when applied in dry-brush manner, dipping the brush in pure or diluted ink, then drying it with a paper towel to give a loose, random texturing in areas of a drawing that may have grasses, bushes, or thick hair. Any misplaced texturing marks may be erased with fine steel wool.

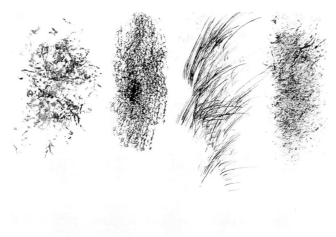

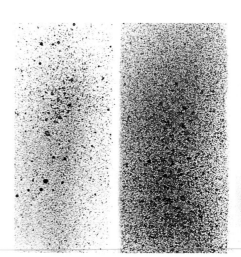

These examples of visual texturing with India ink show, from left to right, effects produced with a wadded paper towel dipped in ink with excess ink blotted off; a cellulose sponge used in the same way; a 3-inch nylon house-painting brush dipped in ink and blotted almost dry; and a #6 watercolor round dipped in ink, blotted almost dry, and splayed out.

These splattering techniques include, from left to right, the use of a toothbrush dipped in ink and "thumbed" to create small droplets hitting the surface; blowing through an atomizer to cover larger areas with splattered droplets; and an example of airbrush application that simply consists of much smaller ink droplets graying the surface.

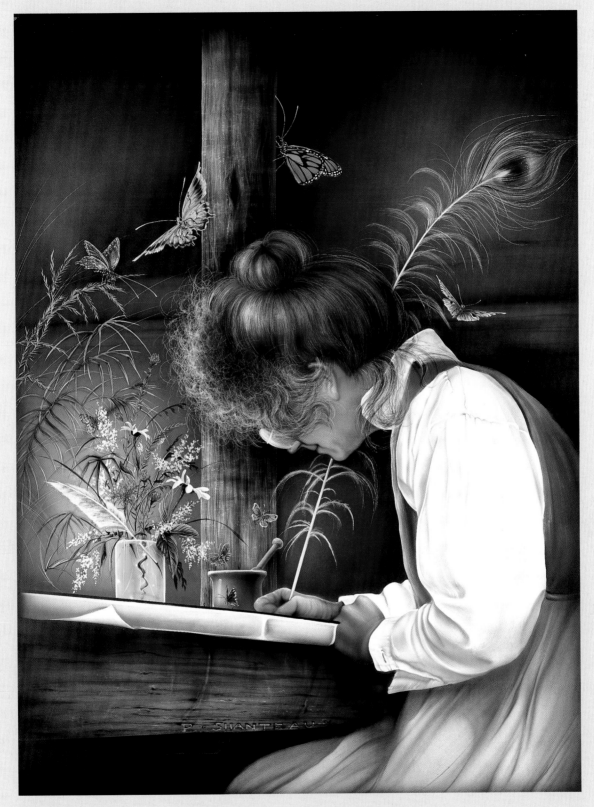

PAMELA SHANTEAU *Madame Butterfly*
40 x 30" (101 x 76 cm).
*In this fanciful piece, Pamela used an airbrush application of acrylic inks in conjunction with
scratching techniques to give the intriguing combination of softness, yet with sharp detail.*

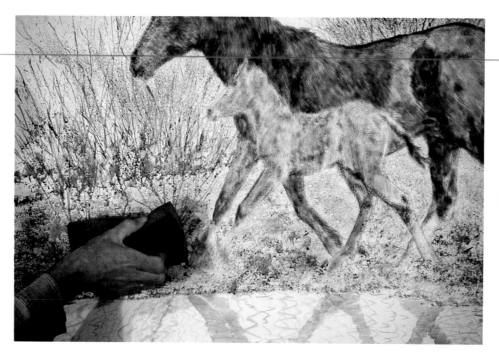

Charles Ewing
Tandem Rhythms
30 x 40" (76 x 101 cm).
Here, I apply a random texture using a sponge and diluted India ink. There is usually a lot of subtle surface variation in natural subjects like a horse, particularly when in motion. Texturing is an attempt to provide this same sense of variation. I will leave some random textures and perhaps dim out others by gentle abrasion with fine steel wool, and remove others entirely.

Sponges, rags, paper towels, cotton balls all offer unlimited possibilities as pigment-application tools. Experiment with found objects of all kinds, such as a handful of dried grass to lay down texture for natural objects or simply to give textural variety to a piece. The principle advantage of this technique is in quickly achieving the "feel" of grass or fur or leaves without having to laboriously draw every detail. For example, once a grassy texture is loosely applied to a landscape, a few blades of grass and seed heads may be rendered accurately, and that small amount of tight detail will carry the rest, telling the viewer that this is a patch of grass.

Splattering tools include an old toothbrush or stiff brushes of any kind and size, dipped in various dilutions of pigment and flipped onto areas of the surface. Pull a thumb over the wet bristles to splatter small areas. The visual texture of pebbles, rocky ground, a weathered adobe wall, or even the pitted face of an old man can quickly be enhanced with this technique.

Airbrushes and atomizers blow paints and inks onto a clay surface in the form of small droplets (with an atomizer) or in even smaller mistlike droplets (with an airbrush.) But remember, whenever you apply pigment to a surface you will change its value (light to darker) and create shadows, the building blocks of form. You also give form a more descriptive texture. For example, if you are painting a rock, describe its rough surface with a grainy application of pigment. Using an atomizer, speckle the rock with various dilutions of ink droplets, going heavier in the shaded sides of the form. On the other hand, if you are painting a billiard ball, the fine mist of an airbrush is indicated to achieve the shadows, direct light, and reflected light of a smooth, shiny ball.

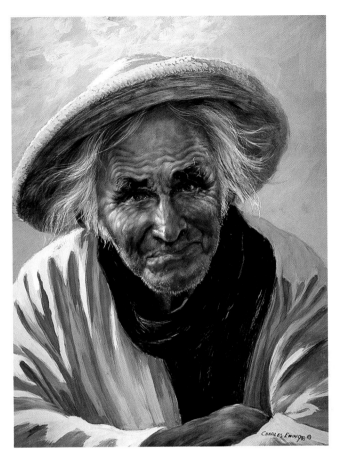

CHARLES EWING *Gentle Man*
18 x 14" (46 x 36 cm).
*This portrait of a neighbor of ours, since passed
away, was done to experiment with the play of
transparent and opaque color. For Paulito's face I
used acrylic inks, scratching back to the white sur-
face with fiberglass brushes for detail, and then
glazing more color over abraded areas. The rest of
the piece was painted with gouache in fairly thick
brushed-on applications. Next to opaque gouache,
transparent color looks all the richer.*

DEBRA EASTLACK
Montana Mountain Woman
14 x 11" (36 x 28 cm). Collection of the artist.
*Debra uses many scratching and lifting techniques,
along with the predominant use of the airbrush,
to achieve this engaging, lifelike portrait.*

Pigment Removal Tools

Talk about forgiveness in a medium! The clay surface is the only art surface on which you may apply paint or ink and then totally or partially remove it. You can make mistakes or playfully experiment endlessly, particularly on the water-insoluble hardboard- backed surface, without compromise.

Any tool with the capacity to scratch, scrape, or abrade may be utilized as a drawing tool or to remove pigment. The artistic purpose at hand will guide your selection of the proper tool for the intended effect.

The tools that I find most useful are described below, but keep an open mind toward finding others of your own invention. As a scratchboard artist, your experiments can lead to fresh innovations and new creative journeys to enjoy.

Scratching and scraping tools of various shapes can engrave very fine lines or scrape broader areas on a pigment-coated clay surface. Ideal for line drawing or cross-hatching to form a gradation of values, such tools may be found without going to an art supply store. (The key requirement is that they be made of hard steel to ensure their continued sharpness.) Use a sewing needle pushed through a small cork that serves as a handle. Or if you have access to old dental tools, they offer good sharp points to work with. A tight grouping of stiff wires of almost any kind is also an excellent tool, especially for cross-hatching. Another choice combines five sharp needles soldered side by side and mounted in a handle, a tool that works well for contour shading and cross-hatching, rendering five very fine lines at one stroke.

Metal-working scribes with a wider angle than a needle offer scratching control almost like drawing with a pencil. The point is conical and travels smoothly enough in all directions to sign your name.

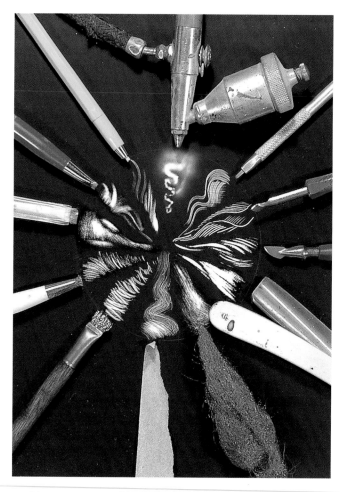

Pigment removal tools include, clockwise from top: air eraser; Ampersand's needle tool; spear-point scratching nib; blade scratching nib; straight razor; #0000 steel wool; 120-grit sandpaper; Ampersand's texturing brush; Micro Mark's Euro tool with fine wire brush; Ampersand's fiberglass tool; Micro Mark's Euro tool with fiberglass brush; Micro Mark's Euro fine-line tool.

Scraping and scratching nibs inserted into penholders are widely available at art supply stores. The most useful blade is one that is gently curved to accommodate scraping lines and areas of varying widths. An old-style straight razor that folds into a protective sheath or handle is extremely useful for very broad to very narrow scraping strokes. A little ingenuity can provide a wealth of similar tools. I have very carefully broken a glass bottle, selected a well-shaped shard of glass, then glued it to a wooden handle, making an extremely useful scraping blade for delicate renderings.

GAMINI RATNAVIRA *Harpy Eagle*
24 x 18" (61 x 46 cm).
Collection of Mr. and Mrs. Michael Dee.
Gamini initially prepares his white clay surface with a light coating of watercolor, using an airbrush to lay down an initial unifying color. The rest of the painting is executed with an almost dry brush, working from dark to light to make it easier to build highlights and details. The finished Claybord piece is sealed with a clear matte varnish and framed without glass, a real benefit in climates of high-humidity, where moisture collects under glass.

CHARLES EWING *Chamisa Garden*
20 x 16" (51 x 41 cm).
For this landscape I used both tube and acrylic inks on a Claybord Textured suface. The grass and willows were created by laying down an initial wash in complementary colors (violet and green respectively), scratching out the grass and willow with a spear-point nib, overglazing with more color, scratching again, and overglazing once more. Final impasto touches in the grass were applied with a palette knife, using an off-white paint.

Abrasive brushes are among the most useful type of tool for manipulating pigment on a clay surface.

Wire filament brushes are similar to scrub brushes, though much smaller, and with a variety of filament stiffness. These tools are excellent for detailed textural effects, such as rendering animal hair. An excellent adjustable wire brush is Micro Mark's Euro tool. Not only can you adjust the filament length for a soft pull or hard pull; you can replace the wire brush insert with a fiberglass filament brush.

Fiberglass filament brushes are perhaps the most useful tools ever devised for scratchboard work. Identical to the adjustable wire brush offered by Micro Mark, this round filament brush, also made available by that company, may be adjusted for a hard-to-soft pull of pigment off the clay surface. What is remarkable about this tool is that it gives the artist very good control over soft-edged removal strokes, like a paintbrush stroke in reverse. Very gradual changes in value can be made with this tool.

Abrasive pads such as steel wool (type without oil) in finer grades are useful for corrections, removal of pigment, or to effect a gradual value change. Roll steel wool into a piece the size of a matchstick to make a soft-edged, small, and controlled highlight. Use larger pads for gentle, repeated wiping over an area of pigment, to gradually lighten values or reduce contrast. Softer grades of steel wool change the surface texture of clay very little. Coarser grades leave more evident scratch marks, which can provide textural effects or pretexture the surface for better pull when using a dry medium. The down side of steel wool is its messiness, creating a detritus of small bits of wire that can work into soft skin and itch like the devil. To protect fingers, thin cotton or latex gloves are helpful.

Synthetic sanding-cleaning pads are carried by hardware stores and woodworking suppliers. Available in various grades of grit, these washable pads can be used and reused many times, and they perform as well as steel wool—without the itch. Cut small strips from the pad for fine work, or use the whole pad for larger areas.

Air erasers made by Paasche can sandblast errors off a technical ink drawing on paper, illustration board, or Mylar. What a perfect tool to remove pigment from a clay surface! Hold it close, and the fine sand will abrade a soft-edged white line; hold it back from your drawing, and it acts like an airbrush in reverse, gradually removing pigment to effect an extremely delicate value change. Larger sandblasters may also be effectively used, for example, to visually texture a whole black-inked, clay-coated panel to a speckled gray appearance.

But note that this tool is somewhat messy, blowing fine sand everywhere. A hooded vent near the work station is recommended, as well as a respirator mask to avoid breathing the dust—and working outdoors with it is preferable.

EXERCISES

With the many tools and techniques for pigment application and removal described in this chapter, not to mention those that you may invent as you go along, I encourage you to invest time in creating a set of "Tools and Techniques" panels for your own use, showing the variety of effects you can achieve on a clay surface. These can be done all at once or piecemeal, adding to your repertoire as you experiment with different surfaces, pigment mediums, tools, and techniques. These permanent panels can be referred to when you're faced with a particular rendering problem in future work.

From my own experience, I know how difficult it is to remember, at all times, the full arsenal of tools and techniques at my disposal. Usually, it is hindsight that makes me wish I had done this or that differently in a particular work. Now, I find that having reference panels on hand is a great asset. I would suggest that you use 5-by-7-inch panels, and keep them loose in a box, mounted on a larger board, or even drilled to fit a loose-leaf notebook.

CHARLES EWING *Tripped Up*
16 x 20" (41 x 51 cm). Collection of Kelly Johnston.
This background was very loosely applied over a pencil sketch with a bristle brush and very wet watercolor. After drying, the tennis shoe silhouettes were cleaned off with fiberglass brushes, repainted with acrylic inks and then scratched.

DOUGLAS SMITH *Don Quixote*
17 x 13½" (43 x 34 cm). Collection of the artist.
With beautiful design, Doug has drawn us into the fabled Cervantes story of Don Quixote.
Much like those impressionist paintings where each brushstroke is discernable, here,
each scratch on the Essdee Scratchboard is evidence of this artist's confident touch.

3 | Ink-Coated Clay Surface

FOR TRADITIONAL SCRATCHBOARD WORK, the best-known and most recognizable surface is ink-coated clay. To create an image using traditional scratchboard techniques, the black ink is scratched off, revealing white clay underneath. Every time the artist scratches, light is created on the subject, with the dark ink left for the shadowed areas. Of course, just the opposite occurs when working with dark pigment on a white surface, where the artist creates shadowed areas with paint or an inked brush, leaving the white of the paper to depict light areas. As noted earlier, if artwork is intended for easy reproduction without shooting halftones, the intermediate gray values may be achieved by cross-hatching or contour-line scratching.

Referring to the demonstration that follows, my aim is to create a work for permanent display rather than for reproduction, so I do not limit myself to pure black-and-white line work. I wish to take advantage of a wide range of gray values between pure white and pure black to increase the expressive potential of the piece. Also, since I intend to use a combination of abrasive and scratching techniques along with repeated applications of wet ink washes to render my grays, a hardboard-backed water-insoluble surface available in the large panel I prefer will serve better. Then I can simply seal my finished work with several coats of acrylic varnish and frame it as I would an oil painting.

INSPIRATION

My model, Leroy, sat for several photos and a few sketches. He kept talking as I worked, telling stories with his head tilted back, his eyes squinting to make out distant images in his mind. I was inspired by the quiet words that rustled from his beard like the skittering of mice on the forest floor. In my mind's eye, I easily saw him by a quiet evening's campfire alone with his thoughts, the only bright spot in a sea of darkness. Having been in campfire settings many times myself, I saw this portrait as an opportunity to share such treasured moments with others.

Portraiture is essentially a romantic endeavor, allowing the subject to speak about personal experience through a facial expression, a tilt of the head, gesture of the hands, or even a wrinkled shirt. The clay surface is particularly suited to portraiture, for it allows the artist to experiment with expression and gesture. It's fascinating to see how the portrayal of a scowling, bad-tempered subject can be turned into a quizzically humorous personality through small changes in a facial line here or a shadow there. For example, in Leroy's portrait, although his lips aren't even seen, notice the slight smile created by his mustache and beard—an effect I achieved only after a bit of trial and error.

DEMONSTRATION: Portrait of Leroy

STEP 1: Initial sketch. Using two different photos and a sketch of Leroy's head, I work out a composition on my panel, deciding on a simple diagonal plan, using the fire to balance the figure. Other diagonals leaning the opposite way, such as Leroy's left leg, lines of his shirt, and bottom of his hat, form stable triangles. The verticals of smoke, his right leg, and arm add to the stable "going nowhere soon" aura of the scene.

STEP 2: Sketch on black surface. The setting's dark background led me to choose a black surface rather than white for this portrait. Now, referring to my preliminary sketch, I draw on the black surface with a sharpened white pastel placed in a holder for easy drawing at arm's length. Using very little pressure, the soft pastel goes on the inked surface without scratching it, and marks may be wiped off easily with a soft cloth for corrections. An alternative method is sketching on tracing paper then transfering the image to a black surface by turning the drawing over, tracing the pencil lines with soft chalk or pastel, then placing the paper on the panel, securing it with tape, and rubbing the chalked image onto the surface. Personally, I prefer drawing right on the inked surface, as it eliminates the stiffness inherent to a traced and transferred image.

STEP 3: Initial scratching. Being careful not to rest my hand on the impermanent chalk drawing and smear it, I redraw the image with a fine-line fiberglass brush, using the pastel marks only as a rough guide while referring frequently to my photos of the model. My scratching is done very lightly to avoid an early compromising line that may be difficult to change later.

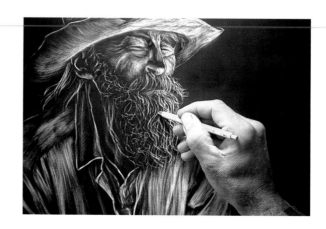

STEP 4: Sanding. I lighten the sky by dragging 400-grit sandpaper across the surface. Fiberglass brushes and #0000 steel wool are also used to develop light areas by abrading off the ink.

STEP 5: Initial ink application. I apply a medium-dark ink wash to the hat brim to define it, but not with too sharp an edge. Using a slightly lighter wash just outside the dark one blurs the edges. At any time, ink washes of different intensity may be painted back into abraded areas to reestablish darks, thus allowing me to work back and forth, removing and applying ink.

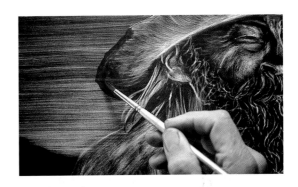

STEP 6: Adding visual texture. With a badger brush, I add darker, hairlike texture to the beard and push back some of the hairs so that I may scratch out brighter ones on top. At this point, I can add other textural richness to the face and clothing by dipping a paper towel in diluted ink, drying it off well with another towel, then patting it in areas of my portrait where there are a lot of natural wrinkles.

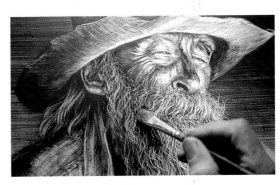

STEP 7: Adjusting edges. At all times during the drawing process, keep in mind the importance of edge quality. To illustrate the difference between sharp and soft edges, note that the boundary of the model's left shoulder is not an important edge for an understanding of the image, so, making it sharp with high contrast (left photo) draws your eye to it, unnecessarily competing with the chosen focus of the piece, the man's face. Therefore, using a larger fiberglass brush and/or ink washes, that edge can be blurred and softened (right photo), setting it back around the corner of the model's arm instead of jumping it out at the viewer

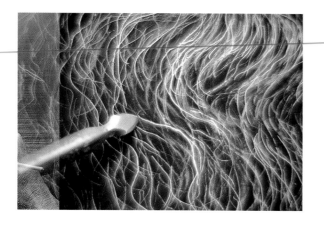

STEP 8: Refining forms. My sharply pointed tool loosely creates scratches to suggest the hairs in Leroy's beard. This mass of hair can then be pushed back in space by applying an intermediate-value gray wash. Newly scratched bright white lines over this low contrast, grayed-out "underpainting" will then seem to stand out in front of the hairs deeper in the beard.

STEP 9: Wash and scratch. This close-up shows dark hairs against the light shirt, achieved by scratching fairly deeply with a sharp nib, then filling the scratches with ink dust or ink wash, a process similar to the scrimshaw technique used on bone and ivory. At this point, the subtleties of value on larger forms (hat, arms) are enhanced with broad washes brushed on or applied with airbrush, the latter being particularly good for gradually darkening the value of an area that had been scratched/abraded for detail.

STEP 10: Highlighting. A fiberglass brush brings out highlights, gradually lightening an area without removing all its details. Areas that have become too dark can be lightened in this way by abrading or scratching, or a particular detail may be brought back from its darker surroundings by scratching.

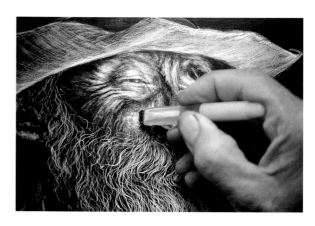

STEP 11: Airbrushing. At various stages I apply diluted ink washes or airbrush spray to areas already elaborated with scratching tools. This reduces contrast in the area treated, also pushing everything back in space, though without destroying the detail already rendered. Tiny droplets of ink that an airbrush lays down over the whole image are easily manipulated with abrasive tools. Pure black ink may be used at any time to reestablish darks or to define a sharp edge.

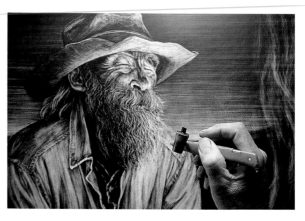

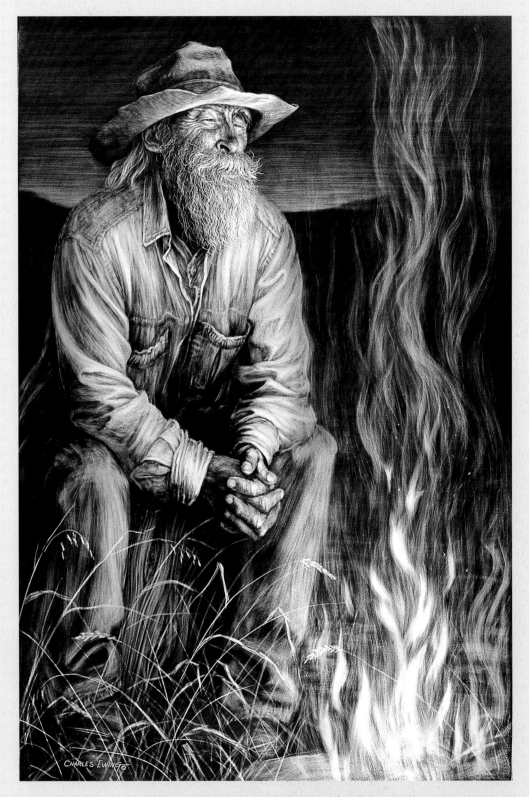

CHARLES EWING *Portrait of Leroy*
36 x 24" (92 x 61 cm)
*As my final step, I apply another light spray to push everything back in space slightly,
then strengthen my focus by scraping off one or two of the most important highlights to
a pure white. The work is then sealed with a few coats of acrylic varnish.*

With a pencil-transfer drawing on the black surface as his guide, Ron Ukrainetz then works with sewing needles and a small scraper. The artist refers to his scratchboard creations as clay "engravings"—actually a good description of the cutting and scratching technique used to produce his work. When the engraving is finished, he applies acrylic glazes to the explosed clay.

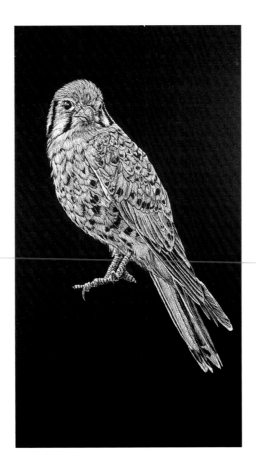

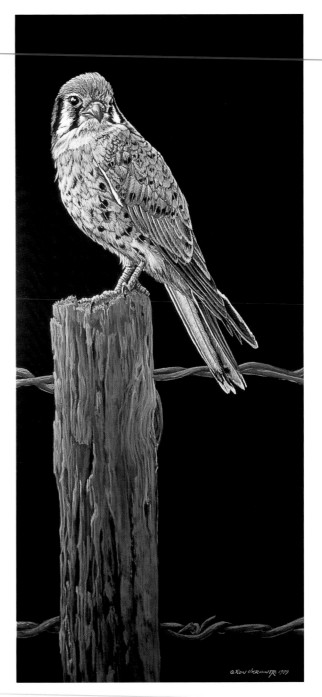

RON UKRAINETZ *Color on a Post*
20 x 9" (51 x 23 cm).
Collection of Eva and Reuben Braunberger.
The fence post was simply painted on top of the black ink with acrylics. Ron sealed this Claybord Black piece with Golden UVLS, an acrylic-based varnish that screens out ultraviolet rays.

CRITIQUING WORK

When I finish a piece, I always put it aside for a period of time. When I come back to it hours or days later, I'll turn it upside down to take the image out of context and view the art only as a combination of light and dark shapes. Casually glancing at it over and over again, I note which elements of the piece seem to catch my eye and in what order. If it happens that my intended focus of the piece stands out first, then progresses through other less important elements, then the piece may be considered finished. If, on the other hand, something relatively unimportant competes for my eye or if the focus doesn't seem strong enough, some adjustments need to be made. In monochromatic work, problems are almost always caused by inappropriate contrast, edge quality, or a confusing drawing (or maybe just bad drawing?). But the beauty of working on clay is that problems can be remedied. By painting errors out with black ink and rescratching, most mistakes can be fixed—as long as the initial scratching wasn't too deep.

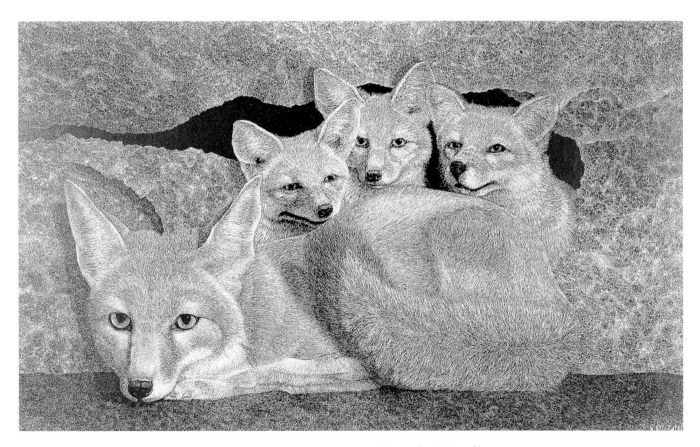

SUSAN LISTER SOLTANI *Kit and Caboodle*
18 x 26" (46 x 66 cm).
*This work shows the beautiful control of value and texture possible
with a fine scratching tool and unlimited patience.*

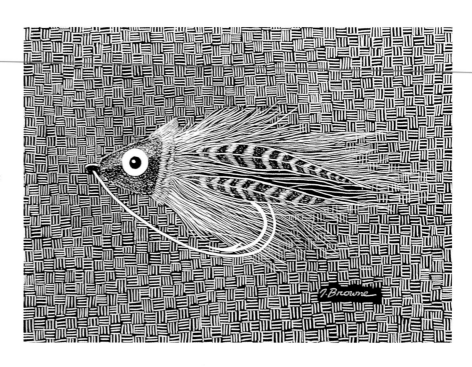

NORMAN BROWNE
Bass Fly
5 x 7" (13 x 18 cm).
Norman used a spear-point scratching nib for the basketweave pattern, and an X-Acto blade for linear detail on the bass fly. Three coats of clear acrylic spray seal the work.

HIROTOSHI MAEDA *Road of the Mountain Alps*
24 x 34" (61 x 87 cm). Private collecton.
This fanciful landscape shows the handsome effects achieved with watercolor on the clay surface.

EXERCISE

Choose a simple image such as a hot dog. Sketch it directly on a black surface (Essdee, Canson, or Claybord Black). Or transfer a drawing on paper by chalking its reverse side, placing it chalk side down on scratchboard, then tracing the image to transfer it to the black surface.

Now, start on one end with a scratching nib, needle, or scribe and begin developing the form with cross-hatching. A third of the way through, switch to a wire brush or an Ampersand needle tool (actually a tattoo needle) and elaborate the middle third of your object. Finish the form with fiberglass brushes, sandpaper strips (400-grit, wet or dry), and/or #0000 steel wool.

This exercise will give you a feel for the many effects possible using different tools.

CHARLES EWING *Hot Dog*
5 x 7" (13 x 18 cm).
I rendered this appetizing morsel in three parts, using a different pigment-removal tool for each. From left to right: a triangular scratching nib, a needle tool, and a fiberglass brush.

CHARLES EWING *Braiding Rope (Portrait of Jake Neal)*
24 x 18" (61 x 46 cm).

Sometimes the artist's emotional content surrounding the subject matter makes it hard to do a piece, as was the case with this portrait. I was so awed by Jake's common-sense wisdom and knowledge of the Colorado wilderness, that I thought any attempt to capture his essence in a portrait would be inadequate—nevertheless, I tried.

4 | *India Ink on White-Clay Surface*

INDIA INK ON A WHITE-CLAY SURFACE is perhaps one of the most versatile and forgiving marriages of a pigment medium and an art surface in the world of art materials. On what other surface can you paint a pure black stroke of India ink, then either scratch detail into it, partially remove it, or totally remove it without damaging the surface?

We have seen how an image can be created on a black, ink-coated clay surface by scratching or abrading ink off to expose white clay, then adding ink back into the image, scratching more off, and so on, achieving dramatic results with high contrast.

Starting with a *white-clay* surface, however, delicate gray values are much easier to achieve, while the option is always there to add strong, pure-black areas of ink. The process is still one of working back and forth, applying ink, then scratching or abrading into it with various tools. Textures can be built up gradually, and on white clay, the artist generally has more control at every stage of the drawing, or as I like to call them, "ink paintings."

For the following demonstration, I have chosen to work on Claybord because this technique in black and white most diverges from traditional illustrative scratchboard techniques with India ink. I hope to show both the versatility and forgiveness of this water-insoluble clay surface and how a scratchboard drawing can be more painterly, loose, and fun to develop.

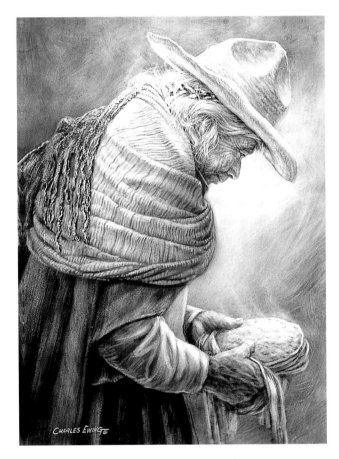

CHARLES EWING *Simple Pleasures*
24 x 18" (61 x 46 cm).
Which is warmer, the tortillas or the old woman's smile? Compositionally, they have equal weight, with the viewer's imagination filling the space between.

71

It can hit your mind like a sledgehammer or catch your eye in a quiet whisper of awareness. Either way, inspiration is that excitement about portraying a subject that artists can't wait to share with others or confirm for themselves. It's the reason we paint, make music, write, or dance.

I find the power and playful grace of horses in motion inspiring, fascinating, and challenging subject matter. One evening, I was videotaping our young gelding, Cherokee, when he suddenly started charging, twisting, and snorting, with the evening sun backlighting strong moving lines that seemed to push their forms along. Upon reviewing the sequence, it occurred to me to combine two of his poses captured on video as if he were playing with his best buddy—which he was. But experience told me that copying photos for a drawing wouldn't be enough, that it would result in a third-gen-

eration stiff approximation of the feelings I had when this horse was cavorting around me, and that was the experience I wished to convey. The video would provide some information, but using animals as subject matter requires live observation. If you plan to depict horses, use every opportunity to study their physical proportions, the rhythmic movement of their legs, head, mane, tail, and torso, the quality of light as it plays over their figures, and how body language can communicate joy, fear, anger, or playful abandon.

Finally, to create the illusion of a horse, we must to some extent use this knowledge to "nail on his shoes," to become him as much as our knowledge and empathy will allow. Thus informed, we may have something worthwhile to say. So, to express it, to help this image come alive on the clay surface, let us turn to the tools of the trade.

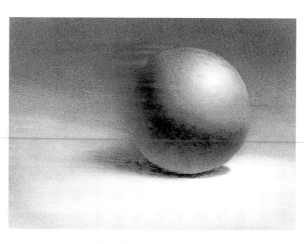

With this chapter's focus on monochromatic images, let us consider their artistic merits, as shown in these two examples of a ball. The red image has the right shape for a ball and a bright color to attract the eye, but without any evidence of value provided by a light source, it lacks three-dimensional reality. The monochromatic gray ball, on the other hand, lacks bright color, but has shadow and a sense of volume and movement. So which says "ball" more realistically?

DEMONSTRATION: Horseplay

STEP 1: A searching sketch. To let my hand and mind experience the lines of motion that define the shapes of horses, their connection to each other, and to the background, I let my pencil search around on the surface. As the sketch takes shape, I listen to what those lines tell me. This drawing process combines both a rational control over the pencil with some chaotic lack of control, producing "purposeful accidents" that are very useful in mimicking nature.

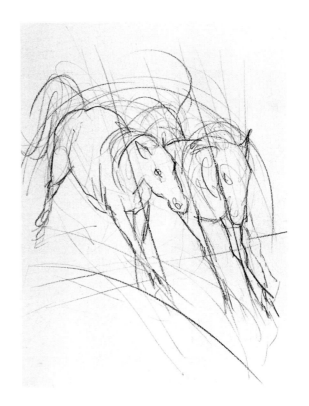

STEP 2: Graphite drawing. Using a soft graphite stick, I refine my sketch. On clay, I'm able to develop my drawing without having to transfer it from paper, and with fine steel wool, make changes with no damage to the surface. In this composition's general movement from left to right, notice how the jawline of the horse on the left approximates the belly line of the horse to the right; how the horse's head on the right flows into the action of his forelegs, with his upraised tail creating a vertical that sweeps down the nose of the left horse; and how flourishes of their manes repeat the curved lines of their rumps.

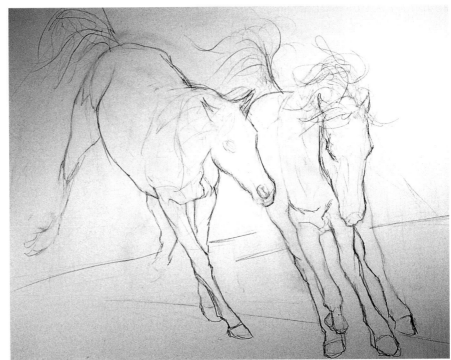

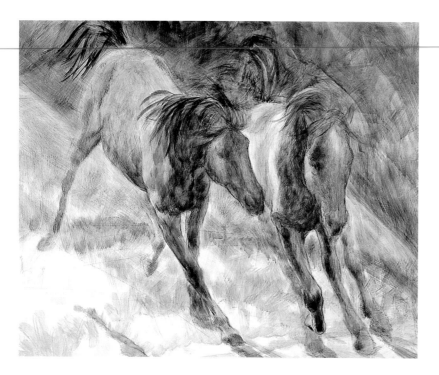

STEP 3: Loose wash application.

My pencil drawing has been reinforced with ink. After allowing it to dry, I begin loose textural applications of a medium-dark wash added to the figures and background without losing the drawing. Where needed, I have rendered the darks of the legs and heads with a brush, and reestablished the edges along the left horse's nose and the right horse's cheek with a cleaning swipe of fine steel wool. As the eye travels over the picture, note how repetitive lines are like visual drumbeats that enhance the rhythmic pounding of the hooves and the rise and fall of the bodies, manes, and tails.

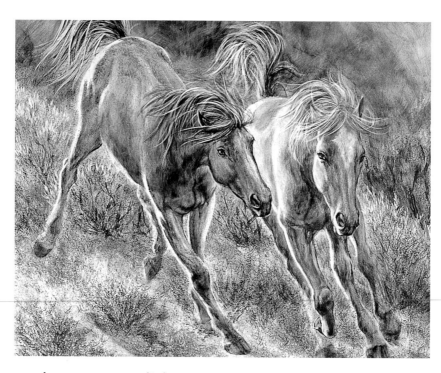

STEP 4: Background texture, more light. I describe the visual texture of sagebrush by moistening a rolled-up paper towel with ink and patting it on the surface to mimic the random confusion of branches and leaves. Where it looks too random, I define some twigs and leaf groups with a sable brush, then reinforce those areas with scratched-out highlights. Lights are reestablished with a fiberglass brush, then I wash the whole piece with an airbrush. This fine spray of ink darkens wash strokes already there and adds delicate grays to lighter areas or where lines were scratched out in previous renderings, pushing the whole image back in space by reducing the contrast among elements.

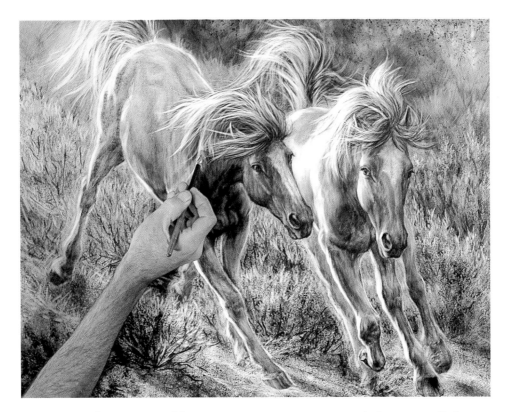

STEP 5: Sanding, scratching. Now the more important lights are pulled out again, using steel wool for broad areas, fiberglass brushes for smaller areas, and scratching nibs for the finest details and sharpest edges, such as some of the hairs of the manes and edges of the forelegs. This process of wash application and highlight scratching continues until the point of diminishing returns sets in—or until I find myself rendering the same highlight over and over with no apparent gain in the overall look of the piece.

STEP 6: Edge manipulation and focus. With fine steel wool, I have gently abraded the hind leg of the horse on the left to reduce its sharp edge. This adjustment lends a sense of movement and pushes that back leg where it belongs, positioned behind the forelegs. Additions of ink washes with a sable brush also help to reduce contrast and blur edges. After another overall airbrush wash application and selected highlight scratching in the heads and forelegs to intensify the focus both in physical space and in importance, I'm ready for my final step.

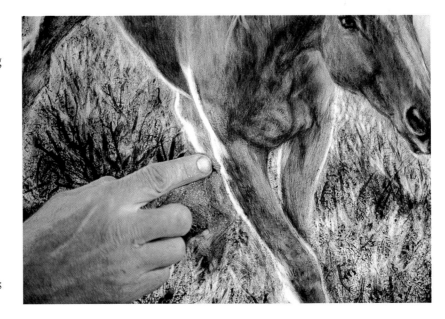

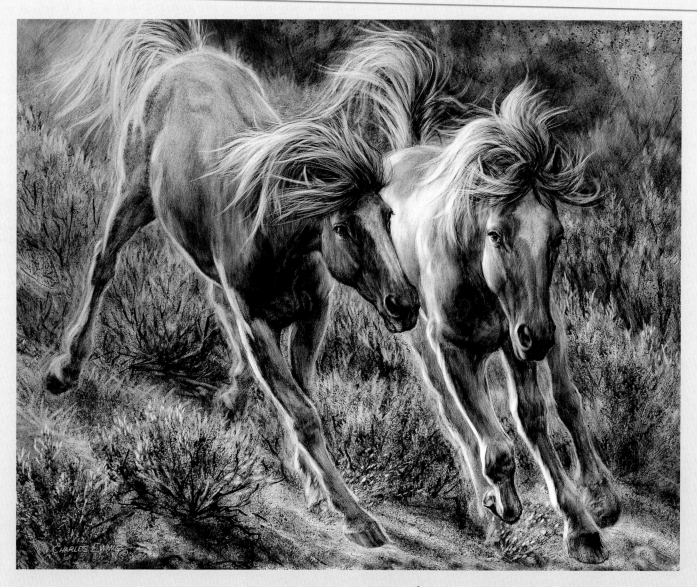

CHARLES EWING *Horseplay*

22 x 28" (56 x 71 cm).
Collection of Paula and John Durcan.

I lay the piece flat and varnish it with acrylic spray, allow it to dry overnight, then spray again, this time holding the can a foot away and moving it evenly but twice as rapidly over the piece. The result is a semimatte finish that reduces glare without masking the richness of values, as will a pure matte varnish. This nonyellowing coating eliminates the need to frame the piece under glass; instead, it is framed as if it were an oil painting.

DEMONSTRATION: In Tandem Rhythm

STEP 1: Initial sketch. This abbreviated demonstration focuses on the technique for portraying textural elements such as the willow background shown here lightly sketched in graphite on Claybord.

STEP 2: Texture. I introduce a physical texture by brushing on clay mixture, trying to mimic the textural direction of those willow clumps.

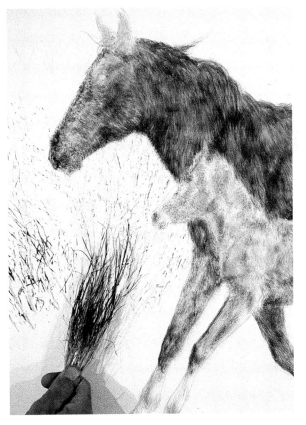

STEP 3: Darks. After completing the horses, I apply darks for willow clumps, using dried grass dipped in a dark ink wash.

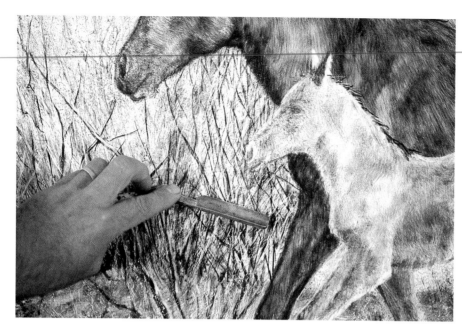

STEP 4: Scraping.

I have put a general light wash over the whole willow area with a wide brush to darken it so that when the textured surface is then scraped with the flat edge of a straight razor, as shown, the raised clay ridges are cleaned of ink, giving these willows some highlight areas.

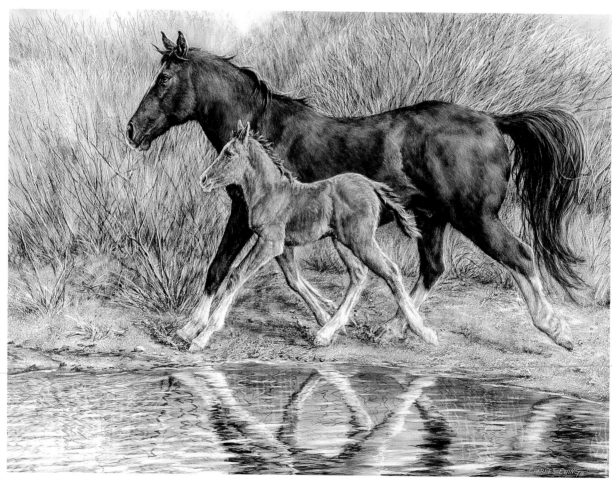

CHARLES EWING *In Tandem Rhythm*
30 x 40" (76 x 101 cm). Courtesy Andrea Stevens Gallery.
*Before declaring this work finished, I repeat the foregoing process several times
to impart greater and greater depth to the clump of willow branches.*

COMBINING TECHNIQUES

As seen in the following pieces, the combination of several techniques in each work produces a rich range of effects unique to the clay-surfaced scratchboard medium. For example, sumi ink, water soluble when dry, may be used along with India ink, insoluble when dry. Sumi is easily lifted or pushed around on the surface, while multiple layers of India ink wash may be scratched in between.

CHARLES EWING *Young Bulls*
24 x 36" (61 x 91 cm).
On a hardboard-backed clay surface, I used sumi ink to portray the water, it being easy to redissolve with a damp brush or cotton swab to lift the ink, wiping off ripples in the stream. India ink, which does not dissolve when made wet again, was used for the rest of the image where ink application alternated with ink removal by scratching and abrading in the rendering of the bull moose and background. Other techniques include: for the forest background at upper left, several applications of light-gray ink wash applied with the corner of a sponge; and to create those final bright highlights on the animals' backs and antlers, I used scraping tools.

CHARLES EWING *A Gathering of Spirits*
24 x 36" (62 x 91 cm).
Initially, I had six dancing ravens inked into this image. Since there was not enough elbow room, I simply erased two with fine steel wool, and replaced the background.

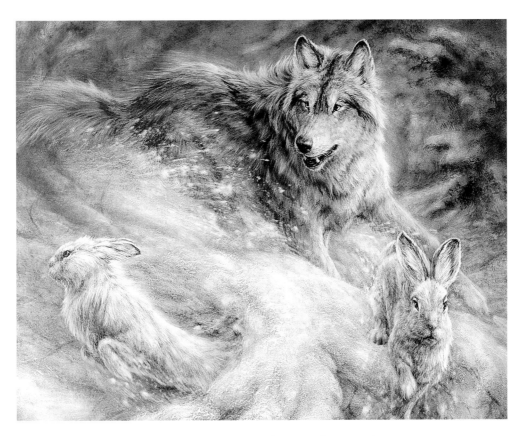

CHARLES EWING *Distracted Pursuit*
22 x 28" (56 x 71 cm).

To get the look of grainy snow and animal fur, I textured a hardboard-backed panel with clay mixture, after my graphite drawing was complete, but before any ink was applied. The piece was then developed with various tools: airbrush for the background behind the wolf's head; a scratching blade to describe the swirling snow over the rabbit on the left; then a fiberglass tool to blur the edges.

CHARLES EWING
Freedom to Roam
24 x 36" (61 x 92 cm).
Clouds in this piece contribute lines of movement, sweeping from the right down to the left, the same direction the antelope are going. Sumi ink was used for the clouds, cotton swabs then put to work moving the redissolvable ink around and to soften highlights. The foreground sage was heavily textured with a liquid clay mixture before any ink was applied.

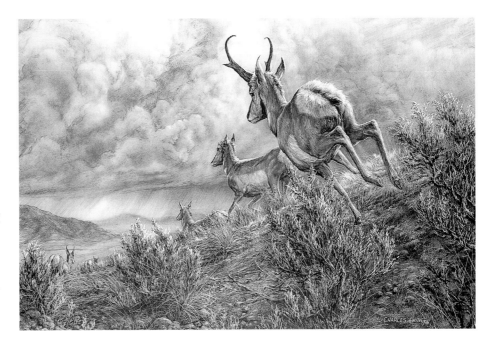

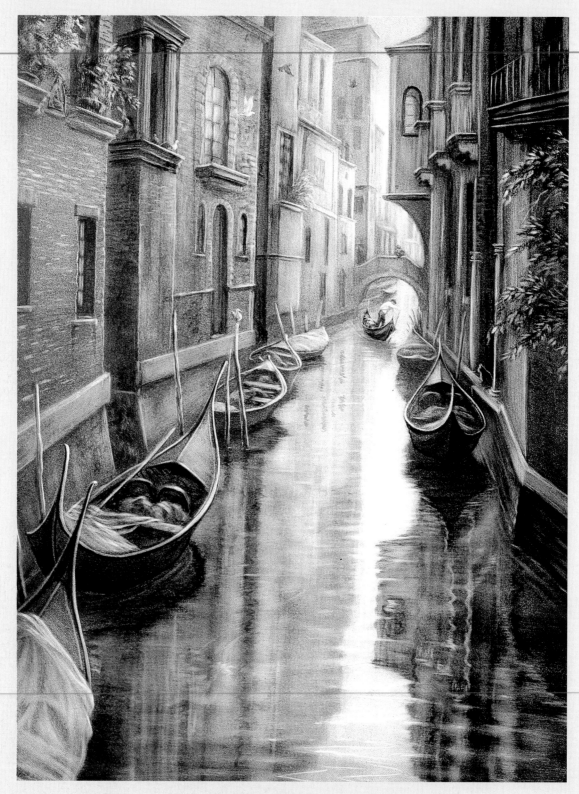

CHARLES EWING *Venice Reflections*
24 x 18" (61 x 46 cm).
For the canal, I chose sumi ink because it can be redissolved with a wet brush or cotton swab and pushed around to produce a fluid, watery look. For the buildings, I used India ink as it allows for multiple applications with scratching in between.

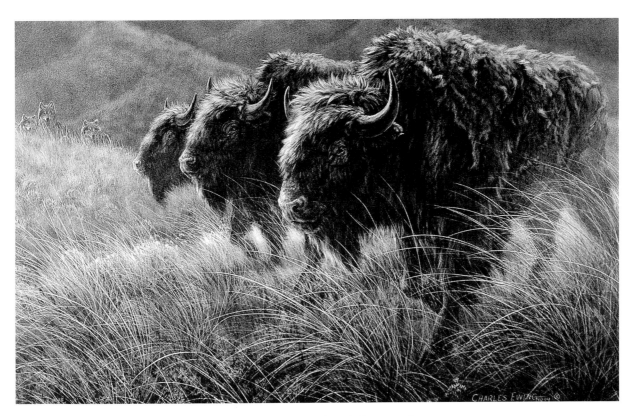

CHARLES EWING *Surviving as One*
24 x 36" (61 x 92 cm). Collection of Nancy Freshour and Dick Smith.
Scratching out detail on the shaded side of the buffalo, then graying it with an airbrush, easily achieves this backlighting effect. The airbrush for soft application and #0000 steel wool for soft removal of inks are the two most useful tools to manage value on an ink painting created on a hardboard-backed clay panel.

CHARLES EWING
Dutchman's Backyard
12 x 16" (31 x 41 cm).
Collection of Kathryn and
Daniel Rominski.
Sumi ink on Claybord Textured allowed me to move the ink around, lifting certain areas with a damp brush and abrading others with a fiberglass brush to achieve the look of water. In the sea grasses, particularly, scratching nibs created individual blades of grass. While a textured surface is scratchable, for very fine detail work, the smooth clay surface is preferable.

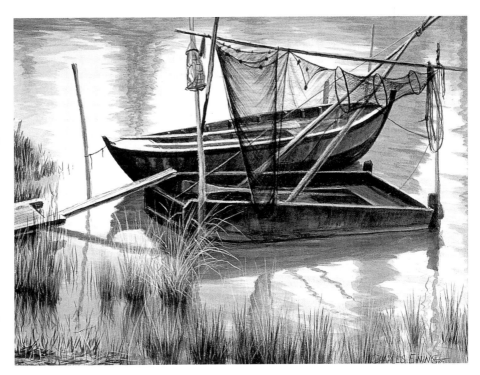

CHARLES EWING *La Timidez*
24 x 16" (61 x 41 cm).
Collection of Wanda and Steve Ericksen.
*Facial expression in a portrait sometimes
requires fiddling around with the features
until the right expression emerges. That is
why the versatile and correctable clay surface
is such a good choice for portraiture.*

CHARLES EWING *Paulito*
24 x 16" (61 x 41 cm).
*With this portrait of my now-deceased neighbor
Paulito, I relied heavily on the airbrush to darken
shadowed areas that had already been elaborated for
detail with scratching tools. Greater contrast adds
drama to a portrait, and in this case, seems to
increase the intensity of the subject's smile, capturing
an important aspect of his look and his personality.*

CHARLES EWING *Quiet Shade*
24 x 16" (61 x 41 cm).
This India ink piece was a compositional experiment to see if the weight of the blank space to the right would balance the subject. I think it does, and it also seems to produce the feeling of being squeezed into the shade by a street bathed in hot sun.

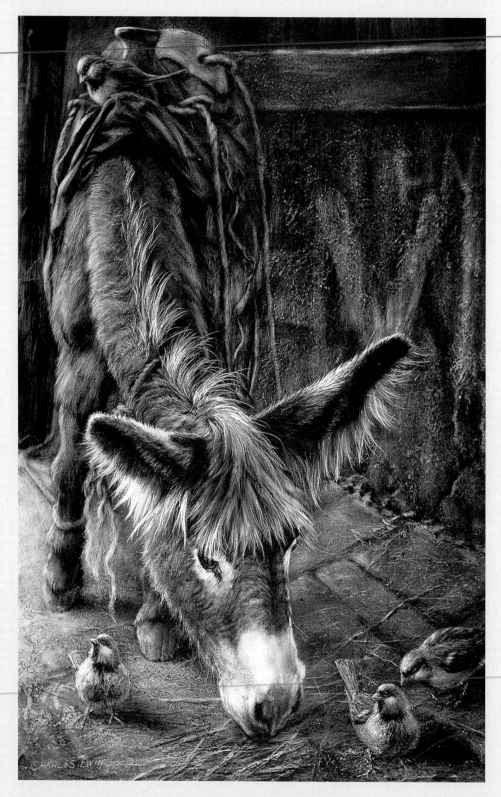

CHARLES EWING *Doing Lunch*
24 x 16" (61 x 41 cm).
This work illustrates how the amount of contrast between a subject and its background
can be gradually built up, using alternating applications with washes and airbrushing,
plus ink-removal techniques employing abrasive tools and scratching nibs.

EXERCISE

Using a soft graphite pencil on a white-clay surface, do a drawing of a ball on a table, with the light source coming from upper left, casting the ball's shadow on the table. Erase and make changes with a pad of #0000 steel wool. When satisfied with the drawing, use the steel wool to dim it out a bit so pencil lines won't interfere later.

Now, dip a #6 watercolor round in a medium-dark wash, then blot it on a paper towel and paint the ball and its shadow on the table a uniform gray. Your pencil lines should still be visible through the ink wash, and your brushstrokes will be very evident. Allow your work to dry.

Take a pad of #0000 steel wool, roll it into a soft ball the size of a marble, and bring back the light where it strikes the ball by abrading the ink so white clay is reexposed. The highlight area—the strongest light on the ball's surface—will be the whitest; then it goes gradually with a smooth transition to light gray, where the light source barely strikes the surface.

Clean off the table except for the ball's shadow, then very gently abrade the shadow so that it appears a bit lighter and with fuzzier edges the farther the shadow is from the ball. Now, on the shaded side of the ball, show reflected light coming from the bright table, slightly illuminating the right edge of the ball by very gently abrading, making it slightly brighter near the edge and dimmer toward the center of the ball. Now add some pure black ink where the ball touches the table. All the elements of a three-dimensional image are now in place.

For a variation on the above exercise, let's turn to something radical. Cut off the top of the ball and either: make a bowl; bore a hole in it and turn it into a vase with flowers; or pound nails all over it; or turn it into a golf ball, a baseball, or a lemon. For this exercise, simply draw your change onto the image with a pencil, erase the ink with steel wool or a scraping tool that doesn't pertain to the new object, and paint in the ink that does. This exercise will show the freedom you have working with a clay surface.

The ball at left was rendered with India ink on a hardboard-backed clay surface, using dry-brush techniques with a sable brush for shading application, then abrasive tools—fiberglass brushes and steel wool—to bring out highlights. For the image on the right, I essentially cut off the top of the ball, hollowed it out, and bored two holes through it. All of this was done by erasing with abrasive tools and reapplying ink where needed.

JERRY DAVIDSON *Still Life with Vermeer*
20 x 16" (51 x 41 cm).
For this masterful work, Jerry transferred his initial drawing to a panel surfaced in white clay,
going over his graphite tracing with a fine brush and diluted India ink. Then he spread broad
areas of thin acrylic color with a wide brush until the whole surface had some color, with the
ink drawing still visible. Using small brushes to build up detail, he applied short brushstrokes
in some areas, cross-hatching in others, and tiny pointillist dots of paint for finest details.

5 | *Color Mediums on White-Clay Surface*

COLOR IS PURE WHITE LIGHT separated into the different wavelengths of the rainbow's hues. It permeates everything our eyes perceive. It can be dark of value or light, brilliantly pure-hued or neutralized to a gray. It can vibrate with energy when contrasted with its complement. It can jump out at you or recede into the distant mist. In all, color offers the artist a formidable bag of tools with which to engage the eye, build images, and capture the viewer's imagination.

In this chapter, we'll explore a few techniques in step-by-step demonstrations using acrylic colors on the clay surface. Then you'll see examples of other work created with a variety of color mediums, including a few mixed-media approaches. There are so many potential techniques for the clay surface, I hope that this introduction to a few will open the door to your own artistic experimentation, resulting in many more.

ACRYLIC

Acrylics, both standard in tube form (sometimes called standard body color) and in liquid form (inks), are particularly suited to clay surfaces. Both forms generally contain pigments ground to a very small particle size that adheres well to clay without permeating the surface as do some dye-based paints and inks. This allows us to remove pigment when using scratch-art techniques, as long as the paint is kept relatively thin in areas to be scratched into.

Acrylics dry forming a plastic, water-resistant film that, if too thick, will preclude scratching back into. However, this same waterproof quality of the dried paint, even with very thin washes, allows the artist to overlay additional washes without dissolving the previous layer. This is extremely useful in conjunction with scratching techniques, allowing one wash to be elaborated for detail or texture with scratching tools, then painted again with another wash, perhaps of a complementary color, then scratched again, repeating the process until the buildup of paint is so thick that no more scratching can be done.

Because acrylic inks have strong intensities in thin applications, pigment can be applied in various ways then scratched through, reexposing the white clay beneath to achieve visual texture, create detail, adjust edges, or to place another object such as a leaf in the foreground. In addition to creating these thinly painted areas of highly rendered detail or texture, we may also apply very thick impasto strokes of tube acrylics with a brush or palette knife, giving an image a wide range of paint quality, from thin, delicately rendered transparent areas to thick opaques. Another option in planning a piece is to make use of a commercial clay mixture to texture the whole surface of a panel

evenly or just some areas selectively, following brushstroke directions and varying textures for different parts of your composition. Such texturing must be allowed to dry before any color is applied.

Any of the cardboard-backed or hardboard-backed scratchboards described earlier are compatible with acrylic techniques. Also keep in mind that many of the techniques demonstrated for acrylics may be used with many other color mediums, but each differs a bit in handling, so it's wise to experiment on scraps of board before attempting a project.

DEBRA EASTLACK *Bolivian Indian Woman*
20 x 16" (51 x 41 cm). Collection of the artist.
Many interesting techniques contributed to the success of this beautifully expressive portrait. Debra uses acrylics, working almost entirely with an airbrush, masking with acetate, and she also airbrushes through fabrics such as cheesecloth, burlap, or lace to create patterns. She pushes and pulls the paint to create texture with erasers and uses various scratching tools. Her fine details are applied with colored pencils.

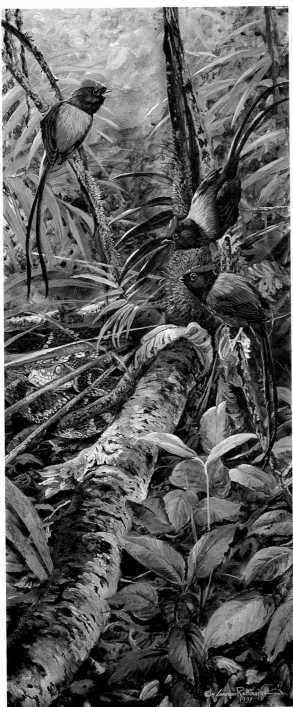

GAMINI RATNAVIRA *Blown Cover*
22 x 10" (56 x 25 cm). Collection of the artist.
*Gamini initially prepares the white-clay surface
with an undertone color—cadmium yellow,
cadmium orange, or blue violet—to develop
brilliance for his striking wildlife artwork. He uses
a dark-to-light technique with acrylics to develop
depth of field and strength of color. After drying
his work, he frames it without any glass.*

CHARLES EWING *Within the Deep Woods*
36 x 22" (92 x 59 cm).
*This piece was initially heavily textured with a
commercially produced clay mixture. Acrylic inks
were then built up as I scratched out detail and tex-
tures between layers. Some of the final lights were
applied with impasto strokes using a palette knife.*

Walking through the forest, we rarely see everything around us right away. More often, it's on second or third glance that we begin to discover nature's hidden content behind our mind's first assumptions. The work featured in this next demonstration plays with that idea, using many of the techniques possible with acrylics on a clay surface.

My aim is to have the image appear at first glance as if it's mainly an abstract arrangement of colored shapes, with the yellow of aspen leaves being most predominant. But there, hidden behind the leaves, is the secondary focus, the penetrating eyes of a wolf. My hope is that once those eyes are discovered by anyone looking at this piece, they will captivate not only the viewer's attention, but the viewer's imagination as well.

As for technique, in this one piece you'll see a range of thin, transparent acrylic ink colors richly elaborated with detailed scratching then overglazed with more color. Thick impasto strokes of tube acrylics also animate this piece, applied with a bristle brush in some places and a palette knife in other areas.

This demonstration shows how pure color straight from the tube or ink bottle may be used straight or neutralized to varying degrees by mixing in that color's complement. Two examples are violet mixed with a little bit of yellow; and ultramarine blue mixed with a bit of red-orange. You'll also see how pure hues jump forward spatially and relative to the receding neutrals.

My colors include the very warm cadmiums—yellow, orange, and red light—complemented by cool violet, blue violet, and ultramarine blue, plus black with some burnt umber to warm it up. The image is rendered with thin, transparent applications of acrylic inks, which can be scratched into for intensity. Impasto applications provide further drama.

There are three distances to contend with: the leaves in front, the wolf next, and the background behind the wolf. Using a muted, subtle palette behind the wolf helps to keep attention squarely focused on the foreground.

Finally, when depicting nature, I find two competing forces at work: the tendency toward predictable order, and the opposite tendency toward chaos. The balance of the two usually results in an interesting beauty, something that is identifiable yet different. With this in mind, in this demonstration, as in much of my work, I try to keep alive a little bit of undirected chaos in my brush or scratching tool to allow that accidental difference to occur.

DEMONSTRATION: Aspeneyes

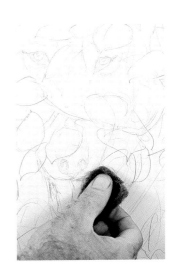

STEP 1: Initial sketch. On my white-clay surface, I begin by drawing the wolf, then putting in some leaves, keeping my initial sketch very loose as I gradually refine shapes.

STEP 2: Graphite drawing. Using #0000 fine steel wool, I erase unwanted lines. There is no need for precision at this point, and repeated erasing won't change the original surface texture noticeably. When the drawing is complete, any overly dark lines that may later interfere with color may be gently abraded.

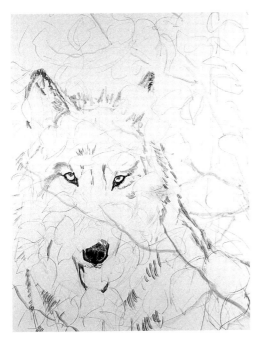

STEP 3: Ink-wash overdrawing. I overdraw my initial graphic "landmark lines" with a medium-gray India ink wash, hitting all the elements important to the composition. By reinforcing the drawing this way, I will not lose the composition when I begin to apply a lot of loose color washes to the wolf and background.

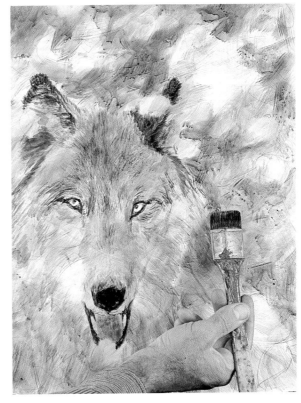

STEP 4: Initial washes. Acrylics, even in thin washes, are waterproof when dry, so I can paint in areas of pure violet, let it dry, then glaze over it with a yellow wash, which visually neutralizes the violet. Another way would be to mix violet ink with a bit of yellow to neutralize it before painting it on. Each method looks slightly different but accomplishes the purpose: to give the vibrant yellow leaves a subdued background of complementary color.

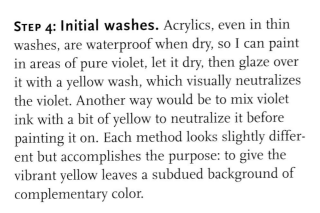

Step 5: Fur texture. If I had to draw every hair of this wolf, one by one, I would drop the brush and go fishing! Instead, I begin to create the look of fur with pigment application, working fast, refusing to be trapped in detail rendering. Using a dry-brush technique, I describe the wolf's coat with short brushstrokes that follow the natural growth direction of the fur.

Step 6: Defining the leaves. Using a fiberglass brush and tube acrylics, I work on the leaves, following my original pencil lines in certain places and changing them in others, paying attention to the shapes of individual leaves as well as to leaf groups. At this stage, I'm still drawing, searching for what looks good, what works best.

Step 7: Initial scratching. Fur on an animal serves to keep it warm. For the artist, animal fur holds a wealth of information about the skeletal form underneath it by the way hair lies on the body. Here, I use a scraping tool to help describe the form of the skull by having my scratched lines follow the natural direction of the animal's hair.

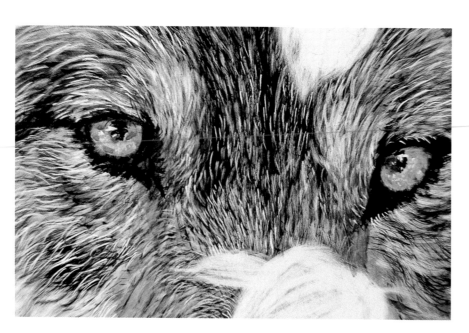

Step 8: More washes, more scratching. After coloring the eyes, I apply more thin acrylic washes to create richer fur, rescratching to enhance its texture further. Using a #6 round brush, I lay down acrylic washes of red browns, then some blue violet for shadows falling on the wolf's muzzle. At this point, a general wash of a light blue violet over the whole image pushes everything back in preparation for bringing the leaves forward.

STEP 9: Impasto application. Up to now, only thin washes have been used. Now I load a palette knife with cadmium yellow mixed with white and trowel it on the leaves in a thick impasto. Such bright color next to neutralized violet jumps out—but where some leaves become too dominant, I load a wide bristle brush first with blue violet and a bit of white, then cadmium yellow and a bit of white and scumble—lightly drag the brush across the surface. This tends to mass some leaves together by reducing contrast between them, neutralizing color and blurring their edges, giving the focal point, around the wolf's head, the sharper edges and more brilliant color.

CHARLES EWING
Aspeneyes
18 x 14" (46 x 36 cm).
Collection of the artist.
Finally, I seal the painting with three coats of spray varnish, which intensifies the color, particularly the darks, and protects the work when framed, without having to use glass.

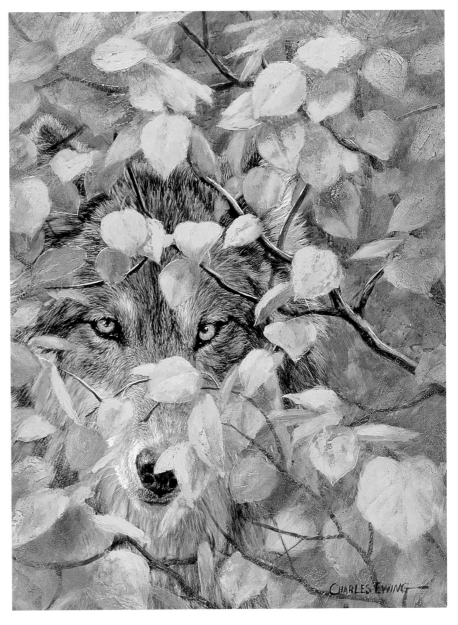

95

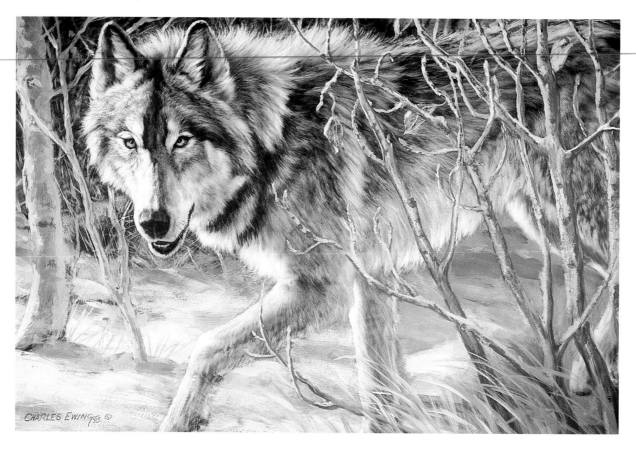

CHARLES EWING
Natural Nobility
16 x 34" (41 x 87 cm).
Private collection.
*Another inspiring wolf
scene led to this work, an
experiment in paint quality.
The figure is painted with
rich, transparent acrylic
inks, using some textural
scratching between applica-
tions; the background is in
thick, opaque gouache—a
paint-quality combination
that adds depth to the work.*

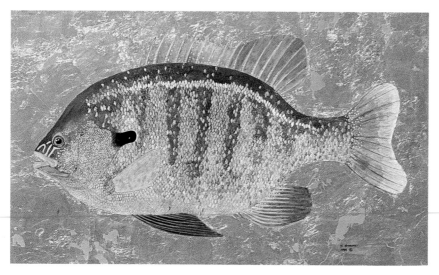

NORMAN BROWNE *Longear Sunfish*
14 x 24" (36 x 61 cm).
*This is an excellent example of a mixed-media technique on the white-clay
surface. Norman cuts into the clay with an X-Acto knife, carving out the
scales, then paints those with transparent acrylic glazes and sometimes
adds an impasto drop of paint on each scale to lend reflectivity and
sparkle. The metal leaf gives the piece an art deco feel.*

DEMONSTRATION: Compliment to the Morning

STEPS 1, 2, 3, 4. In this compressed demonstration, my earlier step was drawing in graphite on the white-clay surface. Now I've added acrylic inks to the face, using an airbrush. Highlights on the cheek, nose, chin, and other areas are abraded off with a fiberglass brush. The background is painted in with bristle and sable brushes. Note how I overlap into the figure area to allow a continuous stroke of background color. This overlap can be cleaned off with steel wool in order to repaint it.

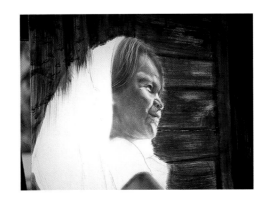

STEPS 5, 6. The dress and shawl were executed first by spreading tube acrylic paint on a glass sheet, allowing it to dry, then soaking it off in a pan of water. The paint films were then carefully applied to the image, using acrylic medium as the glue.

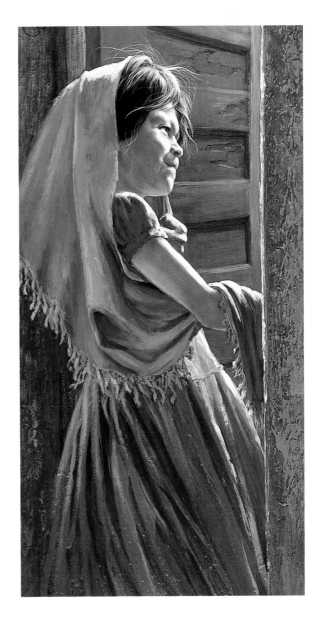

CHARLES EWING
Compliment to the Morning
28 x 14" (71 x 36 cm).
Collection of Elaine and Edwin Ramos-Salazar.
The finished work shows a wide range of paint quality, from transparent airbrush with details scratched into it to describe the model's skin, to the very textural collage sections of her dress and shawl.

97

With gum-arabic as its binder, watercolor pigment is held to a support, but may be redissolved by rewetting it. Even in thick applications, it remains a bit chalky and can be easily scratched into with pigment-removal tools. This differs from acrylics, which resist scratching when thickly layered. But watercolors painted in thin washes allow the white support—paper or clay—to show through the paint, giving it its unusually luminous appearance.

Watercolors may be used on all clay-surface products, but the one that most resembles watercolor paper for wash effects is Claybord Textured, which is more absorbent than other scratchboard supports. The beautiful expansive washes, perhaps the signature quality of transparent water-color work, are achievable on this clay surface, though to a slightly lesser degree than on fine watercolor paper. However, a textured clay surface offers watercolorists some advantages over working on paper.

Since its mineral surface contains no organic fibers, textured clay delivers a light-fast white that won't yellow. Being able to abrade or scratch watercolor pigment on its surface offers a whole new bag of tools with which to manipulate images to create highlights, textures, or insert objects over a background color by scraping out shapes, then repainting them.

Because pigment particles sit on top of the reflective clay surface, as opposed to working into the fibers of watercolor paper, intensity of transparent color is excellent. For soft highlights, lifting of color is easy using a damp brush, cotton swab, or sponge. However, the drawback of this quality is the difficulty in glazing over paint already

applied without redissolving or otherwise disturbing that paint. One solution to that problem would be a mixed-media approach, first using acrylic washes, which dry water-proof, then going over those with watercolor.

Finally, painting on the rigid hardboard support allows a watercolor piece to be sprayed with acrylic varnish and framed without needing glass protection. This both intensifies color and gives viewers a more intimate appreciation of a painting.

KAREN VERNON *Sprite*
14 x 11" (36 x 28 cm).
This graceful, fluid composition and luminous range of watercolors are enhanced by the fact that the textured clay surface allows all the pigment particles to stay right on the surface, lending added brilliance to Karen's palette.

GOUACHE

This is also a water-based paint known for the opacity of its colors, as opposed to the transparency of watercolors. But like watercolor, its pigment is bound with gum arabic, allowing dry paint to be redissolved with a wet brush. Versatile gouache can be applied in thin washes or thick impasto strokes. Of course, the combination of opaque gouache and transparent watercolor in a mixed-media approach can take advantage of the best qualities of each medium, producing a compelling work of art.

ANN SCHLUEDERBERG *Festooned Bayou*
16 x 20" (41 x 51 cm). Private collection.
Ann used a sharp-edged cosmetic sponge to lift most of the lights while her watercolors were still wet,
to help her get the earthy, tactile textures that distinguish this painting on white clay.

99

CASEIN

Casein pigments have a milk-protein binder. The paint dries quickly on clay and adheres well. It becomes more brittle than other paints with age and is less susceptible to cracking when painted on stiffer supports such as the hardboard-backed clay surfaces. Nevertheless, very thick impasto strokes should be avoided because of casein's propensity for cracking. And as with acrylics, pigment-removal techniques may be employed on thin applications, but as thickness builds up, it becomes increasingly hard to scratch through casein, so keep that in mind when using this medium.

STEPHEN QUILLER
*Aspen Patterns,
Mt. Nelson*
48 x 32" (122 x 82 cm).
Collection of the artist.
*Using casein on the white clay
surface, Steve said he went
wild with trying all kinds of
scratching techniques and
brushwork. His energy is still
emanating from this
compelling image.*

Colored Pencil

Both the softer, water-soluble colored pencils and the harder, wax-based variety work well on clay and, of course, both let you scratch highlights and abrade for different values. A wide range of sticks can be found in both types of pencils. The wider ones are very useful for larger pieces or broad strokes; thinner pencils are best for detail work.

Encaustic

Imagine the sense of history encaustic painters must feel working with a medium the ancient Greeks invented, melting beeswax, mixing pigments into it, and painting it on a surface. Artists have just recently begun using this medium on clay surfaces, and there is a lot of room for experimentation, particularly with scratching techniques.

ANNELL LIVINGSTON *Love Letters from Taos*
10 x 8" (26 x 21 cm).
Being heat resistant, clay is a good choice for encaustics, as in this intriguing piece. Claybord has an absorbent surface, ensuring that the melted wax encaustic base will adhere well to it.

MAGGIE TOOLE
Hourglass
24 x 36" (61 x 91 cm).
By applying thin washes of acrylic color to the clay surface before working with her wax-based colored pencils, Maggie has created a surface that is more responsive than raw clay would be in producing this sensitive mixed-media piece.

Oil

Oil painters have several ways to approach scratchboard. Using the white-clay panel, paint may be applied to the dry clay; or the surface can be saturated with a medium before painting; or the surface can be partially or totally sealed with acrylic or gelatin. For painters who usually work on canvas that they cut and stretch themselves, using a readied clay-coated panel also offers a time-saving convenience.

ELIAS SAN MIGUEL
The Letter
28 x 24" (71 x 61 cm).
Collection of Dr. Ramon
and Yolanda
de Leon.
Elias began this work by applying a thin coat of burnt sienna and raw sienna acrylic paint mixed with a little gesso. When it dried, he rendered a comprehensive drawing of his subject, then underpainted to establish form and shadows. After that dried, he glazed the entire surface, thinning his oil paints with Liquin medium and using steel wool plus curved and pointed nibs to create highlights and tonal values. The artist notes that he always waits at least six months before varnishing his oil paintings, using a mixture of gloss and matte picture varnish to obtain the satin sheen that finishes this exquisitely detailed work.

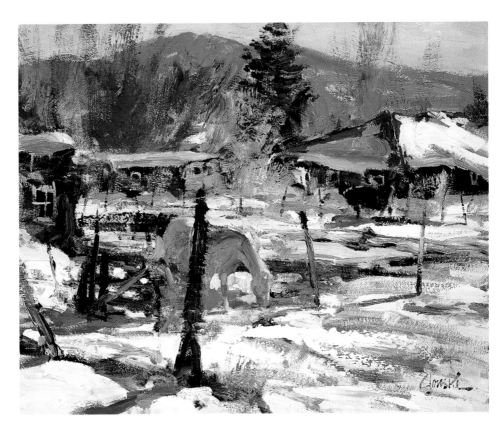

WALT GONSKE
Taos in Winter
16 x 20" (41 x 51 cm).
Walt enjoys using this
unique oil-painting
surface for on-location
work. The white-clay
textured surface absorbs
the linseed oil out of his
initial paint strokes,
leaving them almost dry
to the touch within a few
minutes. This advantage
enables him to overpaint
almost immediately, with
very little mixing
occurring on the surface,
producing this handsome
painterly work.

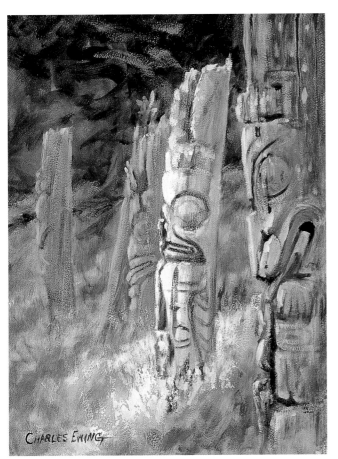

CHARLES EWING *Haida Legacy*
12 x 9" (31 x 23 cm). Collection of the artist.
This on-location painting was created on a com-
mercially textured clay surface at the ancient
village site of Ninstints on one of the Queen
Charlotte Islands off the coast of British Columbia.
Together with seventeen other small pieces brought
back from a two-week painting trip, this was
simply stacked with the others in a suitcase; only
the paintings done on the last two days required
separation in my paint case for further drying.
Back in my studio, I coated this piece with an
alkyd medium, applied a few transparent oil
glazes, and brought some of the lights up in value
with impasto strokes.

CHARLES EWING
*Por Amor del Alma
(For Love of the
Soul)*
16 x 24" (41 x 61 cm).
Courtesy of Alexandra
Stevens Gallery.
*Claybord Textured
offers the oil painter
excellent control in the
execution of a piece,
resulting in paint qual-
ity that varies from the
quietest matte look of
washes to the shiny
look of impasto strokes.*

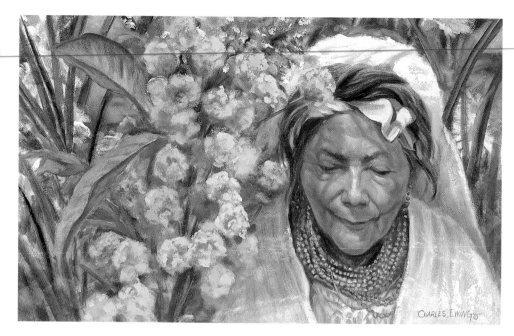

EGG TEMPERA

There has been quite a bit of successful egg tempera work done on the smooth white-clay surface, but to my knowledge, not much experimentation has taken place on textured clay. However, its more absorbent and grainier clay surface may reveal some useful qualities for artists who use egg tempera and would enjoy trying out new ways to work with it.

GEORGE-ANN GOWAN
Light Conversation
24 x 36" (61 x 91 cm).
Collection of Tom Sebring.
*Particularly for larger
pieces, it is a real time
saver to be able to paint
on a panel already pre-
pared for egg tempera
work, as George-Ann did
in creating this fresh,
appealing painting on a
hardboard-backed, white
clay surface.*

EXERCISE

This exercise shows how versatile acrylic can be on a clay surface. Look at how the illusion of spatial depth or three-dimensionality can be projected in a simple painting of grass.

Choose two complementary colors such as violet and yellow, blue and orange, or green and red. Paint a background wash of medium-dark value with the darker color of the two, and let it dry.

With a blade or nib that will scratch narrow to wide marks, scratch out a bunch of grass blades.

Now mix another thin wash with the dark color, plus a bit of its complement, and, with a dry brush, color the white scratches you previously made. Allow it to dry.

Scratch out more blades of grass, crossing over the previous ones if desired, and paint these scratches with yet another thin dry-brush wash, this time mixing your two colors half and half. Allow it to dry.

Scratch once more, making grass blades on top of what you already have, then paint over it with a wash predominately of your lighter color. At this point, you should have grass blades at several different depths as you look at your work.

Now, to create a few blades that really stand out from the others, use a small palette knife (a matchbook cover works just as well) and undiluted paint right from the tube. Mix your lighter color with some white, load the edge of your knife with paint, and apply it to the surface as a very thick line of paint for every grass blade you want to make stand out. The difference in paint quality between the thick, opaque pigment and the neutralized, thin, transparent paint on those grasses hidden behind your emphasized blades imparts an obvious spatial depth, even though it is painted on a flat surface.

CHARLES EWING *Grass*
5 x 7" (13 x 18 cm).
Using a dry-brush technique and a watercolor mop brush, I laid down red violet first, applying it in a textural way to imitate grass, then scratched out some grass, dry-brushed over that using a mix of red violet and yellow, then scratched again, dry-brushed a brighter green, scratched a few accent highlights, and finally, painted a few impasto grass blades.

CHARLES EWING *Shelter of Innocence*
24 x 16" (61 x 41 cm). Lithograph printed on white-clay.
Rather than being printed on paper, this offset lithograph (monoprint) is one of an edition of 150 copies printed on Claybord. With very subtle India ink washes added by airbrush and additional detail scratched into every individual print, each looks just like original art, and on the hardboard clay-coated surface, is every bit as permanent.

6 | *Printmaking with the Clay Surface*

Up until now, it would have been unusual to find mention of printmaking in a book devoted to scratch art. But today there is common ground between the two disciplines, thanks to the new water-insoluble, hardboard-backed clay surfaces that are suited to printmaking techniques. Some of these methods (relief, intaglio, lithography) employ the clay surface as a printing plate, while others (intaglio and monotype) use the surface in the way paper would be used, to receive images from conventional printing plates.

If clay panels could not withstand repeated wetting and drying, they would be of no use to printmakers. But Claybord Original and Claybord Textured, the clay surfaces used in the following demonstrations, are absorbent enough to accept water, slightly softening and expanding the clay without damaging it or its hardboard support. When dried, the clay hardens and shrinks slightly, regaining its former integrity.

Some of the scratch-art techniques covered in previous chapters are equally applicable here, resulting in unique prints. Another advantage is that these methods require minimal studio equipment and expense, and no chemicals more caustic than vinegar and paint thinner. All techniques involve transferring an image created on a printing plate to a clay or paper surface. In the transfer process, of course considerably more pressure is exerted by an etching press or flatbed press than by hand, but for those without access to such equipment, good results can be achieved with certain techniques through hand printing.

I must confess to having little formal training in conventional printmaking, so I find it very rewarding to be able to produce prints from a clay surface. By sharing with readers my experiments in this realm, I hope others will see the potential of these techniques and adapt them to their own creative endeavors.

If you look at the work in this chapter with one eye on what has been discovered so far, and the other aimed at your own experiments with printmaking, still more fresh and exciting methods are bound to emerge.

RELIEF PRINTING

Relief printing of multiple images from a carved woodblock is a method that's been known for a thousand years. Carved areas of the block are left blank, while uncarved areas receive ink and transfer it to printing paper, producing white lines for carved areas against an inked background. Fine carving by master woodblock printers requires years of diligent practice. However, a clay surface can deliver fine relief work executed by artists of moderate skills, since clay is very easily scratched into with sharp instruments, a process more easily con-trolled than carving into wood.

In the following demonstrations, the first, by master printmaker Julia Ayres, shows conventional relief-block cutting, using the unconventional clay-surface blocks.

The second demonstration shows a process that involves more delicate line scratching into a clay surface, creating recessed areas that receive no ink. The final print looks like a traditional scratchboard drawing with white lines on a black background.

CHARLES EWING *Lace Shawl (detail)*
10 x 8" (26 x 21 cm). Relief print, oil-based ink, white-clay plate.
The relief cut, or in this case scratched, into the clay surface "block" may be surprisingly delicate and yet still register on the print. A suggestion for experimentation would be to combine this scratching technique with the more traditional cutting techniques described in the next demonstration.

DEMONSTRATION: Grandcat

STEP 1: Preparation. For this work, artist Julia Ayres chooses a three-color print process, requiring a different plate for each color. She begins with three Claybord blocks cut to equal size. First, she cuts the block to be printed last, which is to act as her key block. Then she inks the block black and prints it on smooth paper. While the ink is still moist, she prints the paper on the face of the other two blocks. This way, all blocks read the same and are in reverse to the final print.

STEP 2: Yellow block. When this block is cut, Julia makes sure the areas that are to remain the color of the paper are cut first. She also cuts areas to be printed blue. The block is printed with yellow ink on white paper.

STEP 3: Blue block. Working on this block, Julia cuts the areas that are to remain the color of the paper, as well as areas where yellow is to show.

STEP 4: Blue plus yellow. Then she prints the blue block on top of the yellow print.

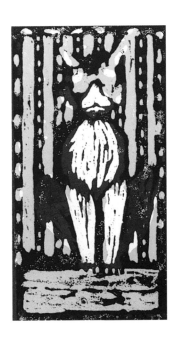

STEP 5: Black block. Now the key block is inked black.

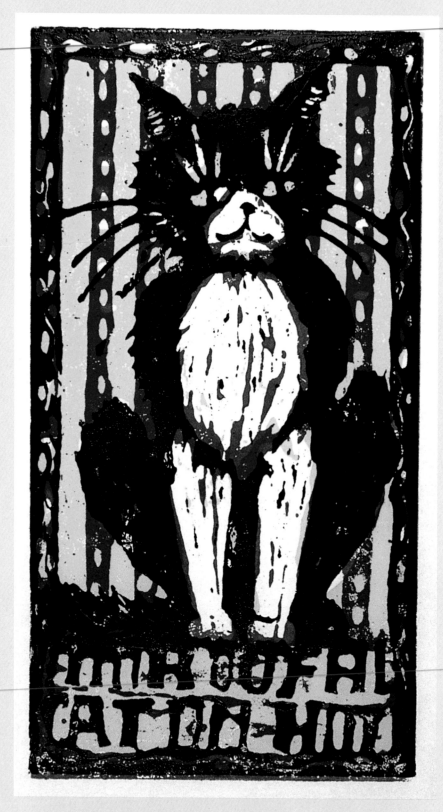

JULIA AYRES *Grandcat*
7 x 3" (18 x 10 cm). Three-color relief print from clay-surface blocks.
The black block is printed on top of the previously printed combined
colors to complete this three-color artist's proof.

DEMONSTRATION: Lace Shawl

STEP 1: Initial sketch. My graphite drawing on the white-clay, hardboard-packed panel can be changed up to twenty times using fine steel wool as an eraser.

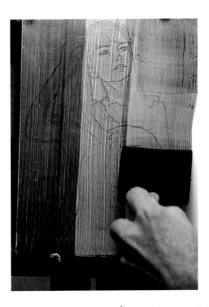

STEP 2: Gray wash. With a wide sponge brush, I apply a medium-gray watercolor wash, allowing my graphite drawing to remain visible for my next step.

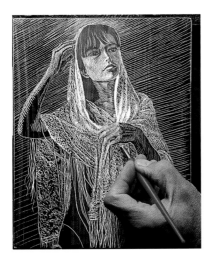

STEP 3: Initial scratching. Using my graphite drawing as a guide, I scratch with a triangular nib, applying more pressure where I want deeper, wider lines. (This step is comparable to cutting the design into clay print blocks in the previous demo.) The wash lets me see the white lines resulting from exposure of white clay, previewing how final prints will look: white lines on a black background.

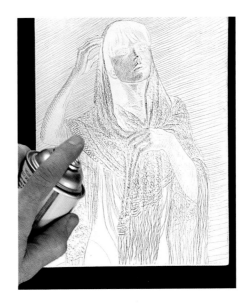

STEP 4: Varnish. After sponging off the watercolor wash and letting the plate dry, I seal it with two thin coats of clear acrylic varnish, spraying evenly and being careful not to fill up fine scratches with varnish. After it dries thoroughly, I go over it lightly with 600-grit sandpaper to remove any irregularities in the varnish.

Step 5: Inking, printing. Using a rubber brayer, I ink the plate with successive thin coats of water-based ink, until white areas are an even black. Now I'm ready to print. The paper must be damp; the correct amount of dampness is critical so as not to dissolve the ink into a smeared mess. I soak several sheets of smooth paper for about twenty minutes, stack them between blotters, go over the stack with a rolling pin, and let them set for twenty minutes. To print, I use firm pressure with a rolling pin or the back of a spoon to press the image onto the paper. After several prints are made, if finer scratched lines fill with ink, printing dark instead of white, I simply wash the plate off, let it dry, and ink again for the next print. Of course, an etching press may also be used (with light pressure) for relief prints.

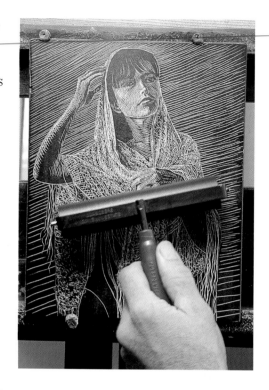

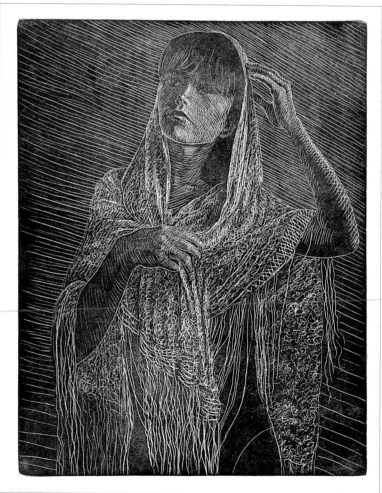

CHARLES EWING *Lace Shawl*
10 x 8" (26 x 21 cm). Relief print,
water-based-ink, white-clay plate.
*Water-based ink produces a lighter image
than oil-based or litho inks.*

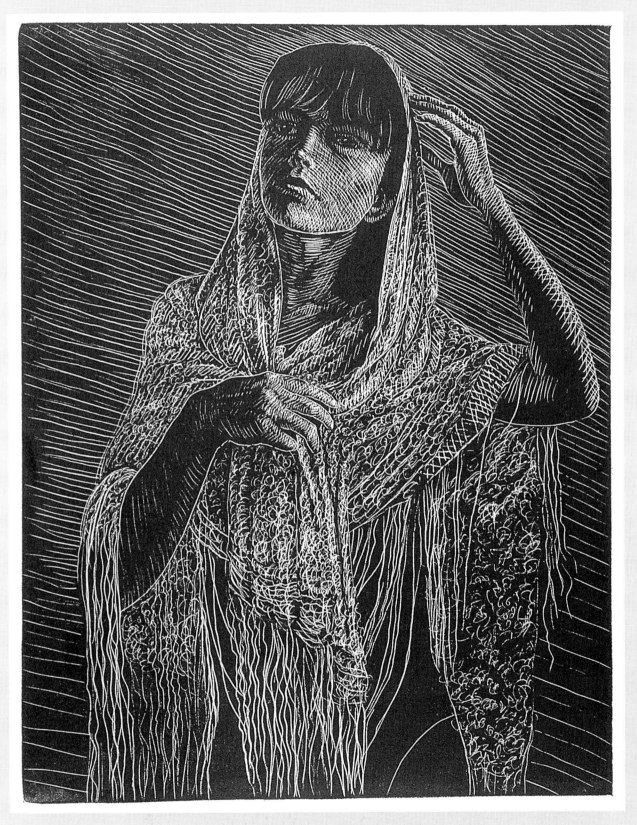

CHARLES EWING *Lace Shawl*
10 x 8" (26 x 21 cm). Relief print, oil-based ink, white-clay plate.
Oil-based lithography ink was used for this print, giving it a sharper, more saturated black image.

The term *intaglio* (Italian for *carve*) encompasses etching, engraving, and drypoint—all of which are based on filling grooves in a copper or zinc plate with ink that is then transferred to a print surface through the use of a press.

In etching, an acid bites away lines in the metal-plate surface; in engraving, a very controlled hand must carve the lines of the image into the plate surface with burins and graving tools; in drypoint, the plate surface is scratched with a sharp needle, creating metal burrs along the line that help hold ink on the plate, a process that is extremely difficult to control. The printed image resulting from these three techniques consists primarily of black lines on a white background, although other techniques such as aquatint and mezzotint can be incorporated with an intaglio to give a range of gray values.

Now in intaglio printmaking, the clay surface can be used as a simpler type of engraving plate to print on paper; and as a print surface, to receive the printed image from a conventional metal-plate etching.

In printing a clay engraving from a clay plate to print paper or printing an etching from a metal plate to a clay print surface, an intaglio (etching) press that exerts considerable pressure is required. Hand printing is very difficult since in the former, the moist print paper must be pressed into the recessed lines on the plate to touch the ink and in the latter, the moist clay must be pressed into the recessed lines in the metal plate.

Here are a few tips for using a press with these two techniques (also generally applicable to all the print techniques in which the hardboard-backed clay surface is used as a plate or to receive a print). First, the pressure exerted by the press, even when very heavy, does not affect the integrity of the clay surface. The edges of the relatively thick clay panel facing the felt blankets of the press should always be rounded with sandpaper or a file to avoid damage to the blankets. Appropriate pressure for a given print technique (fairly heavy for these two techniques) may be adjusted before printing by placing a clay panel along with the same type print paper, protective paper, plastic protective sheets, etc., that will be used when actually printing and running it through the press to test the pressure. Since the clay panels are thick, it helps to lay strips of mat board on each side of the clay plate as a ramp for the roller to climb up to avoid having the plate pushed out of position by the roller. Cheaper proof paper should be used for the first few prints till the image darkens. A good oil-based etching ink works well for these techniques

Clay Engraving

Using Claybord as the plate, engraving recessed lines in the surface is accomplished by scratching with a sharp needle tool. In printmaking, this most closely resembles traditional engraving effects; however, the ease of scratching lines or cross-hatches into clay is more akin to drawing with a pencil than it is to carving lines into a metal plate.

DEMONSTRATION: Cottonwood Rhythms

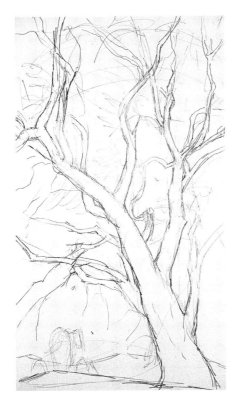

STEP 1: Initial drawing. On the white-clay surface, I use a soft graphite pencil, make changes as needed with fine steel wool, also used to abrade and dim my drawing. Then I spray on a thin, even coat of clear acrylic varnish and allow it to dry thoroughly.

STEP 2: Gray wash. I use a sponge brush to apply a gray India ink wash or rub etching ink on the varnished surface to gray it so the scratching (engraving) of the next step will show up more clearly.

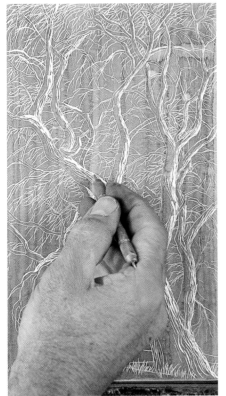

STEP 3: Scratching (engraving). Working with nibs, needles, scribes, and other tools, I scratch out my drawing, being careful not to carve lines that are too deep and wide, as they may not print because of the difficulty of filling them properly with ink. These lines will print as black lines on a white surface.

CHARLES EWING *Cottonwood Rhythms*
10 x 6" (25 x 16 cm).
Clay-surface engraving with etching ink.
This proof, printed on presoaked and blotted paper,
was made with an oil-based etching ink.
After inking the plate, I cleaned the white areas by
rubbing with a flat pad of newsprint paper, leaving
ink only in the scratched lines.

CHARLES EWING *Cottonwood Rhythms*
10 x 6" (25 x 16 cm).
Clay-surface engraving with pigment powder.
Ink pigment in powder form produces a lighter
print than does liquid ink. After cleaning and
drying the plate, I wiped powdered pigment into it,
removed excess powder from "white" areas with a
pad of newsprint, leaving powder only in scratched
lines; then I printed on moist paper. This process is
much easier than applying and wiping oil-based
printing inks.

Etchings Printed on Clay

Traditionally, zinc- or copper-plate etchings are printed on moist print paper. What is printed is permanent; it can't be erased without damaging the paper. But if the surface is clay instead of paper, corrections can be made with scratching and abrading tools. Claybord receives the image from a metal plate in much the way it would on paper. The wet clay surface softens, so that when pressed against the plate with the firm pressure of an etching press, the softened clay works into etched lines to receive the ink, and will even dry with a raised inked line.

Again, since traditional metal-plate etching is not germane to this book, preparing metal plates is not covered. But readers with such skills and an etching press might like to try printing on clay-coated panels.

To print on a clay panel, begin by filing sharp edges (prevents damaging press blankets) of both the metal printing plate and the panel. It's helpful to make a mat-board template with outside dimensions the same as the clay panel, and a window cut to the size of the etching plate. The template helps position the plate on each clay panel before running it through the press. Step-wise ramps flanking the panel prevent movement of the plate as the press roller passes over.

With a sponge, wet the clay panel on both sides until the clay ceases to absorb moisture and maintains a glossy surface. Wipe off excess water. Ink the plate with oil-based etching ink; wipe the nonetched surface clean. Place the damp clay panel face-up on the press bed, putting the template over it, with ramps flanking it. Carefully drop the etched plate upside down into the template window; lay press blankets down gently, and crank the panel through the press. Repeat the process for successive prints.

After allowing ink on each print to dry, you may leave them as they came off press, or manipulate each image with scratching tools, correcting imperfections, removing smudges, and so on. Each print may then be sealed with acrylic spray varnish.

CHARLES EWING *Todos los Santos*
3 x 5" (8 x 13 cm).
Metal etching printed on white-clay panel.
Sealing an etching with varnish and framing it without glass is a first in the printmaking world.

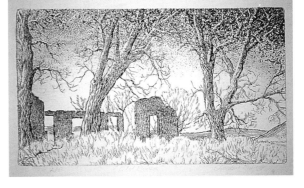

CHARLES EWING *Old Bones*
3 x 6" (8 x 16 cm).
Metal etching printed on white-clay panel.
The plate was over-etched in one place, making the trees too dark. Instead of etching a new plate, I simply scratched off ink on each print.

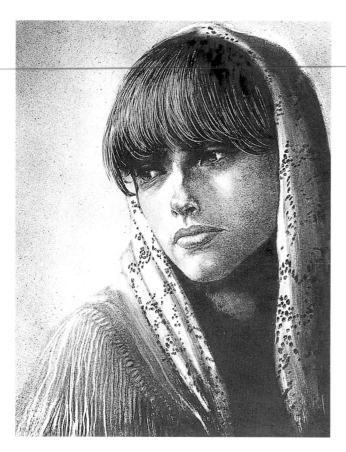

CHARLES EWING *Shawntai in Lace*
11 x 14" (28 x 36 cm). Clay-surface printing plate.
The Claybord panel used as a printing plate may later be preserved by spraying it with clear varnish and framing it for display. This not only gives the artist a presentable "original" to show, but also prevents any further printing from the plate without having to deface it.

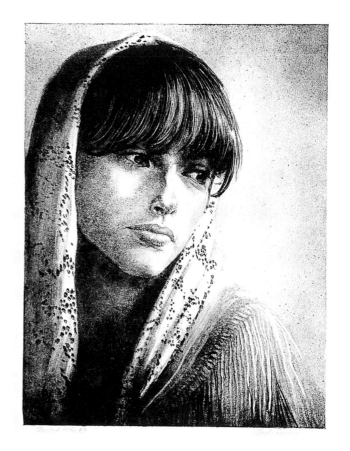

CHARLES EWING *Shawntai in Lace*
14 x 11" (36 x 28 cm).
Clay-surface lithograph on paper.
LithoCoal Powder was used to prepare the clay-surface litho plate that produced this lithograph. The grays are built up with successive applications of powder mixed with alcohol, applied with an airbrush, allowed to dry, manipulated with a bristle brush, and fused to the plate in a kitchen oven. Notice the fine curved lines that shape and define the model's hair, accomplished with a scratching nib after the powder had been melted onto the plate.

CLAY-SURFACE LITHOGRAPHY

When a clay panel is used as a lithography plate, the method is simpler, requires less equipment, expertise, and none of the caustic chemicals common to stone or aluminum-plate lithography. But before looking at the clay surface in the context of lithography, here is a broad overview of this printing method.

Lithography relies on the ability of the printing plate, whether stone, metal, or clay, to accept oil-based printing ink only on the drawn image and to resist ink on areas intentionally left blank by the artist. The inked image is then transferred, via the pressure of a press, to print paper. Inking the plate and transferring that ink to paper is repeated numerous times to complete an edition of prints.

The ability of the plate to receive and resist ink relies on the natural aversion of water and oil. The drawing on the plate is made with greasy or resin-based pencils, crayons, liquids, or powders, all of which accept oil-based ink. Conversely, areas that remain free of ink must maintain high moisture content to resist taking ink off the roller during the ink "roll-up" application. A coating of gum arabic, a substance that readily absorbs and holds water, assists in this task.

Ink of any color will adhere to the greasy or resinous black drawing on the plate. Multicolored lithos may be created, using a separate plate for each color, then printing them in succession. To create fine prints, this process requires skill and good judg-

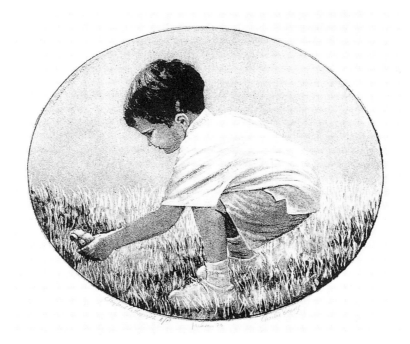

CHARLES EWING *Jackson*
9 x 11 1/2" (23 x 29 cm). Lithograph printed from white-clay panel.
Created as a Christmas gift, this print is from an edition of portrait lithos of my nephew's son. Claybord was cut into an oval with a jigsaw, then the edges were sanded smooth. Unlike traditional lithographs, these show an embossing along the edge of the image from the thickness of the plate, much as you see on etchings.

ment at every step. In fact, with the process being so exacting, most artists opt to have a master printmaker produce their editions, because there are simply too many variables to be learned casually. That is why, at last, clay printing plates enter the picture.

For the clay surface to work as a litho plate, it must be water absorbent and receptive to scratching/abrading throughout the printing process. Two surfaces that meet those requirements are Claybord and Claybord Textured, both white clay, the latter having a coarser surface that may be sanded to a desired smoothness. Used for lithography, these products will not make prints as delicate in value range and textural sensitivity as will conventional lithography, but results can be surprisingly good. And with these clay products, artists may now even produce simple line-drawing lithos in their own studios, printing without the use of a press, substituting a hand roller to apply pressure in transferring ink from plate to paper.

Litho Crayons on Clay Surface

A figure study of a model drawn with litho crayons on a white-clay surface gave me a litho plate that I could take back to my studio to print. The demonstration of that process follows, showing how to take a casual sketch without embellishments and create from it an edition of lithograph prints, all done in the same day. While I used an etching press for my prints, if you don't have one, hand prints can be made, although a lighter image is to be expected due to lesser pressure exerted by the hand versus the etching press.

MATERIALS

black litho crayons
clay-coated hardboard panel
steel wool, #0000
fiberglass brushes
gum arabic
white vinegar
cellulose sponge
cheesecloth
litho ink
glass or plastic rolling plate
rubber brayer (ink roller)
smooth print paper, sized
etching press (or rolling pin)

DEMONSTRATION: Figure Study

STEP 1: Sketch. Using a black litho crayon on a Claybord panel, I made this sketch in a twenty-minute session, then abraded the image with steel wool and fiberglass brushes to adjust the intensity of certain lines and totally erase others. Back in my studio, before going to the next step, I prepare several pieces of print paper by soaking them in clean water for twenty minutes, blotting until semidry, then stacking them between blotting papers.

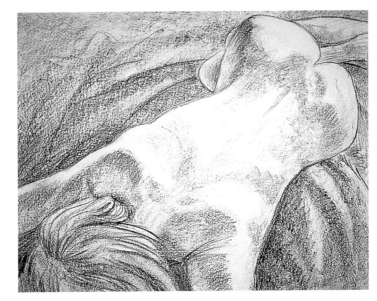

STEP 2: Prepare panel. To clean white areas of fingerprints and any greasy residue smeared from my crayon lines, I use a mixture of a tablespoon each white vinegar and gum arabic, sponged on.

STEP 3: Rinse. Under the cold-water tap I rinse off the panel, rubbing lightly with a sponge. Only fine gray smudges will be removed, leaving the drawing intact.

STEP 4: More gum arabic. Another tablespoon of ~~gum arabic~~ is poured on and rubbed over the whole surface with a pad of cheesecloth.

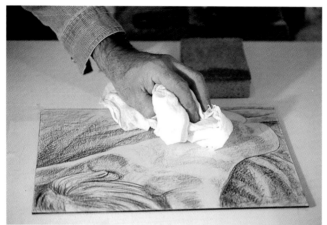

STEP 5: Wipe dry. I wipe the surface with cheesecloth until it appears dry, then allow it to dry thoroughly. This leaves a thin layer of gum arabic on the exposed areas of white clay. The plate may be stored at this point for future printing, but I choose to proceed to the next step.

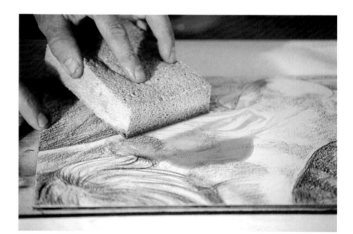

STEP 6: Apply more gum arabic. When ready to print, I apply still another tablespoon of gum arabic, thoroughly rubbing into the whole surface, then drag the excess off the plate with a wet sponge. This leaves many small beads of the water and some gum arabic on the surface.

STEP 7: Roll-up. Preparing to ink the plate, first I roll out litho ink on a glass (or plastic) rolling plate until the texture of the ink is very fine on the roller. Then I roll up the image with the litho ink, using a rubber brayer (roller), making several passes in different directions. I sponge the surface again, load the roller with more ink, and ink the image once more. The residue of gum arabic on the plate is then washed off under the cold tap, excess water is shaken off, and I'm ready to print my first proof.

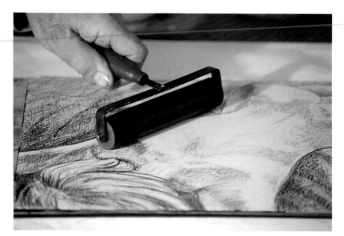

STEP 8: First proof. I place the plate face up on my etching-press bed and position a moistened sheet of smooth print paper over the plate, then crank it through the press. (As noted earlier, hand printing is also possible, most effective with images that have simple lines without large areas that are very dark or delicate.) Before making my next print, I wash off the plate, using a soft cellulose sponge, then re-ink (beginning with Step 4).

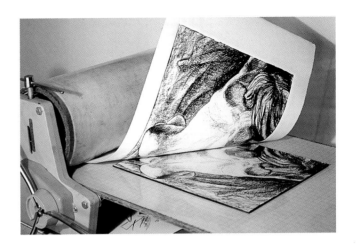

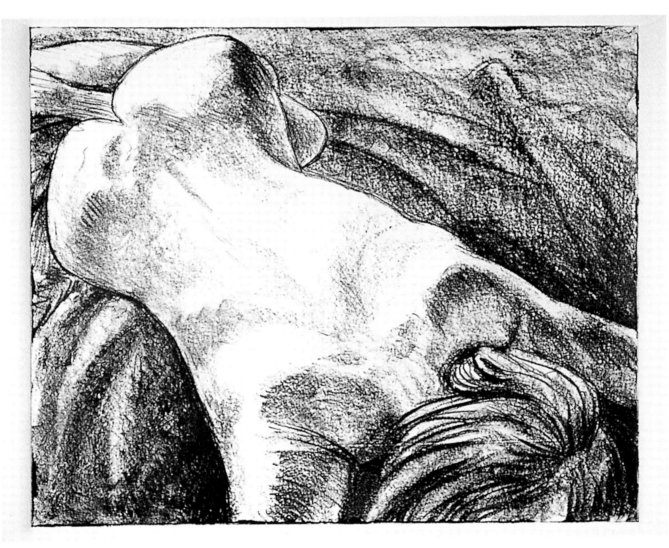

CHARLES EWING *Figure Study*
11 x 14" (28 x 36 cm). Clay-surface lithograph.

STEP 9: Drying proof. I tape the finished print to a piece of hardboard so that it is stretched flat as it dries.

LithoCoal Products and White Clay

The white-clay surface of Claybord and LithoCoal seem to be made for each other when used for lithography. The product known as LithoCoal is available in loose powder form, sticks of compressed powder, sumi-ink paste form, and a black-liquid watercolor form, all of which have special properties that lend themselves to lithography, using the white-clay surface as a litho plate.

The uniqueness of this black powder as a pigment for clay-surface lithography lies in the way it fuses to the clay surface when this type of plate is heated in an ordinary kitchen oven at 250 degrees F. Once melted and allowed to cool, the black drawing marks are permanently bonded to the surface and, more important, are totally impervious to water. Since a lithography edition involves repeated wetting of the clay-surfaced plate, this last quality is vital. Black-powder marks, just like those done with the greasy litho crayon, readily accept litho ink during roll-up.

The sumi ink and watercolor forms of this pigment can be painted onto the clay with brushes of all kinds, splattered, or airbrushed. LithoCoal in powder form may then be smudged to create gray tones or sprinkled through a nylon sieve to create a grainy gray. Once watercolor or sumi ink has dried on the surface, there is no binder that bonds the fine black powder to clay until it is heated, so until then, it may be manipulated and easily wiped from the surface with a brush, cotton swab, or steel wool. An airbrush works well with the watercolor form of the material to spray a fine speckled gray mist on the whole image, with areas subsequently cleaned off to create highlights. This is done before the drawing is heated, which then fuses the powder to the clay. To a certain extent, the compressed stick of this black powder can be used to draw directly on the clay plate, particularly when using Claybord Textured with its grittier surface.

There is more! After the plate comes out of the oven, areas that were airbrushed or have thin washes may be scratched into to create highlights. Then more airbrush, splatter techniques, and compressed-stick detailing may be applied and fused in the oven, then more scratching and abrading, and so on. Artists have the option of totally removing parts of the image even at the last minute, just before it is rolled up with ink and printed.

You will see from the demonstration that follows that the execution of this lithography technique resembles the drawing technique using India ink on the white-clay surface (Chapter 4)—and it comes closest to achieving the finely textured grays found in traditional stone lithography.

MATERIALS

clear acrylic varnish, aerosol

white-clay panel

graphite pencil

steel wool, #0000

LithoCoal compressed-powder
 stick and watercolor forms

airbrush (or soft toothbrush)

cotton swabs

kitchen oven

scratching tools

sandpaper

litho crayon (optional)

liquid tusche (optional)

white vinegar

gum arabic

sponge brush

cellulose sponge

glass (or plastic) rolling pin

rubber brayer (ink roller)

litho ink

smooth print paper

DEMONSTRATION: Forest Rhythms

STEP 1: Initial drawing. Before sketching,
I waterproof the back of the white-clay panel
with three coats of clear-acrylic spray varnish
to prevent warping during the print process.
Using graphite on a white-clay panel, I sketch
the elk full-bodied, draw the trees over them,
then erase lines behind the trees.

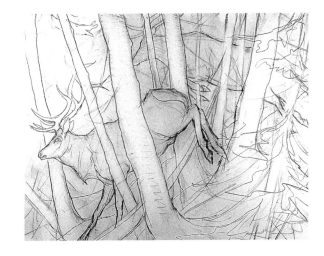

STEP 2: Dimming. With a wad of very fine
steel wool, I abrade my final drawing gently to
lighten it so that it won't be interfere with the
next step.

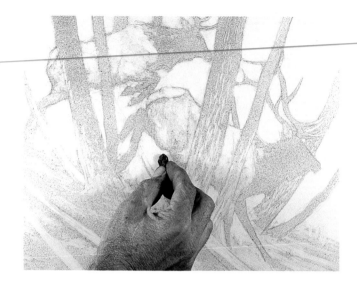

Step 3: Manipulating LithoCoal. I develop my drawing using both a stick of LithoCoal and black liquid watercolor airbrushed on to produce those nice grays. (Alternate methods, without airbrush, are splattering watercolor from a soft toothbrush or simply painting on thin washes.) When the airbrush wash is dry, I pick up loose powder with cotton swabs to create highlights, taking care not to touch any areas I don't want removed.

Step 4: Heat in oven. I set my kitchen oven at 250 degrees and let the clay plate heat for five to ten minutes. (A toaster oven or hot plate is fine for small pieces.) This temperature is not high enough to harm Claybord, as long as it is allowed to cool slowly before the next step.

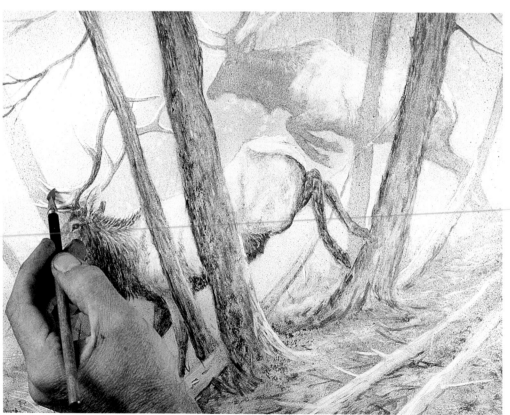

Step 5: Scratching. As long as the black powder is not applied too thickly, I can easily scratch back into the image to reveal sharp or gentle highlights, using scratching tools, abrasive fiber-glass brushes, sandpapers, and steel wool.

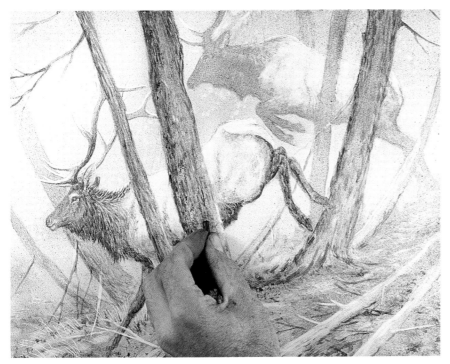

STEP 6: Dark accents. After a second airbrush application, I darken gray areas by repeating the wash, cook, and wash procedure, scratching out detail between applications.

STEP 7: Final highlights. After scraping off final highlights, I think I'm finished with this plate, but won't be sure until after printing a proof or two. If I decide differently, I can always go back and add more darks and cook it, or scratch away more lights. Another option would be to add dark shadings or lines with litho crayons or liquid tusche.

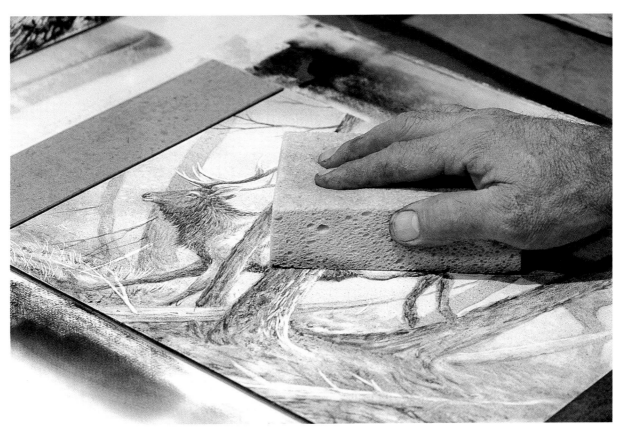

STEP 8: Cleaning plate. Prior to inking the plate, I sponge white areas to remove fingerprints or smudges with a mixture of vinegar and gum arabic, rinse with cold water, and blot with a sponge. Next, I rub a spoonful of gum arabic over the plate with cheesecloth and buff until it appears dry, then put the plate in a warm spot to dry thoroughly.

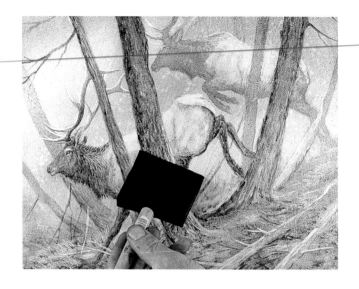

STEP 9: Ready to print. Recoating the plate with gum arabic, I totally saturate white areas, then sponge it off in one swipe of a very wet cellulose sponge, leaving a lot of water and some gum on the plate.

STEP 10: Roll-up with ink. After rolling out ink on a glass rolling plate, I run my ink-coated roller (keeping the ink somewhat thin) over the clay plate, going back and forth several times, repositioning the roller for each pass to make sure the image is evenly coated, and wetting the plate surface between passes.

STEP 11: First proof. My first proof is printed on cheap paper, as it generally comes out too light. But seeing this, I make adjustments to the plate by adding more dark accents.

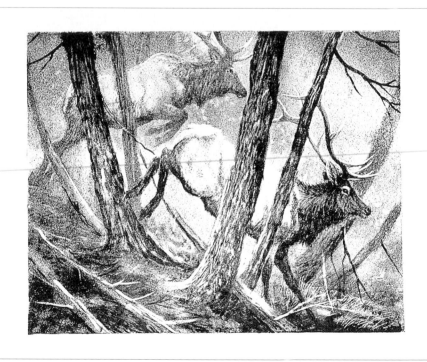

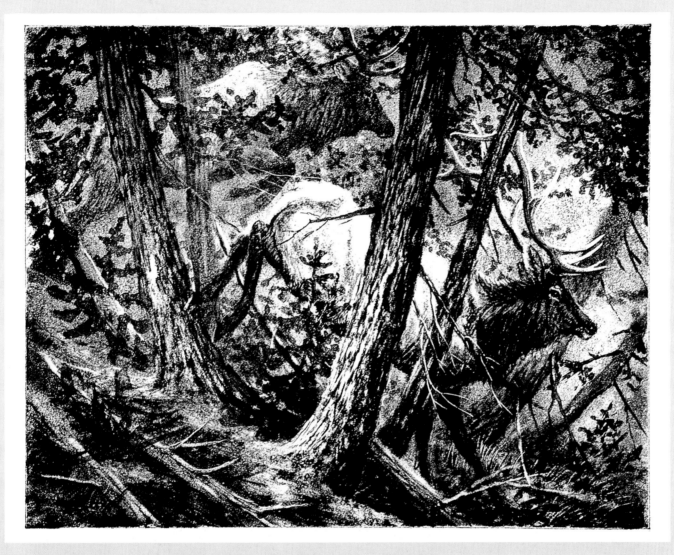

CHARLES EWING *Forest Rhythms*
11 x 14" (28 x 36 cm). Clay-surface lithograph.
Here, you can see the effects of poor judgment. I added more darks, but I prefer the first proof!
As a consolation, at least you may observe what kind of changes can be made to a plate after
printing a few proofs. Remember to presoak paper for about ten minutes before printing.

Engraved Litho Using LithoCoal Powder on a Clay-Surface Plate

The above heading takes a mouthful of words to describe a unique, hybrid printmaking technique incorporating aspects of intaglio (engraving) and lithography. It utilizes the unique LithoCoal powder introduced in the previous demonstration and again used with Claybord as the printing plate. Examples that follow illustrate how resulting prints may closely resemble either zinc- or copper-plate etchings with aquatint shading or fine-line etchings without shading. Once more, this process requires nothing more caustic than gum arabic and vinegar to create the plate on a panel surfaced in white clay, plus other materials listed.

In the demos on the next pages, certain methods offer printmakers a way to create multiple copies of simple images without using a machine press. Prints may be made simply by exerting hand pressure on a roller or back of a spoon to transfer the image from clay plate to paper.

MATERIALS

white-clay panel
graphite pencil
steel wool, #0000
gum arabic
LithoCoal powder and watercolor forms
rubber brayer (ink roller)
glass (or plastic) rolling plate
scratching tools
newspaper
kitchen or toaster oven
cellulose sponges
white vinegar
litho ink

DEMONSTRATION: Bullish Moon

STEP 1: Initial drawing. On a white-clay panel, I draw with a soft graphite pencil, then use fine steel wool to make changes without altering the quality of the surface.

STEP 2: Gum arabic. Using a rubber brayer, I mix gum arabic with regular black watercolor paint on a glass rolling plate. This coat of gray gum, after it's dried, will allow scratch marks made in the next step to be seen easily; coating the drawing also keeps it intact as a guide for scratching, as well as protecting unscratched areas from accepting the LithoCoal powder in Step 5.

STEP 3: Grayed plate. The gray gum mixture rolled over the plate may be uneven, but that's not important, since this layer will be washed off later. But I'm careful not to make it too thick, or it will be difficult to scratch through.

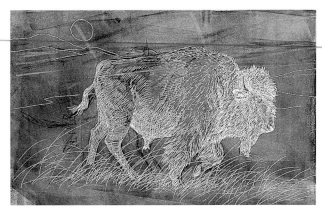

STEP 4: Scratched image. I have used various scratching tools to produce this image as I followed the drawing under the gum. Note that I am working with reverse values; white scratches will later be dark inked lines on my print. Make sure your hands are dry so that the gum layer is not disturbed in the white areas.

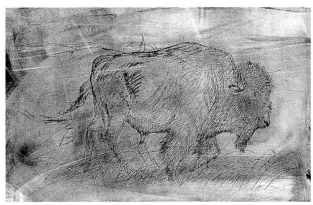

STEP 5: LithoCoal powder. With the image complete, I rub LithoCoal powder in the scratches. Then I wipe off excess powder, using pads of newspaper this time. Any remaining fine dust doesn't concern me; it will come off in a later step. Now, I have black lines on a light background, the way the print will appear, making corrections easier.

STEP 6: Heating. My clay plate goes into a toaster oven set at 250 degrees for five to ten minutes, to fuse powder in the scratches. It also fuses dust on the gum coating, but this will wash off later. After this heating, when the powder is completely fused, I allow the clay plate to cool, then repeat the powder application (Step 5) and wipe off excess powder. The plate is cooked again and cooled. This double application insures that deeper scratches will be filled with fused powder.

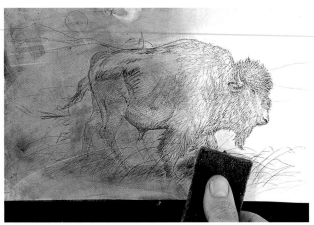

STEP 7: Washing off gum. I wash off the gray gum arabic with cool water, sponging lightly. Sometimes there will be some fused powder in undesired white areas. This is usually due to a gum layer that is too thin or that has been partially dissolved with wet hands. Gentle rubbing under the tap with fine steel wool will remove it.

Step 8: Adding grays. Now I add gray shading to the plate image by airbrushing or hand brushing the watercolor form of powder on the plate, allowing it to dry, then lifting it for highlights. The plate is toasted, cooled, and ready to print, except for scratching off a few precise highlights. Considerable scratch work as well as additions of litho crayon or tusche can be done at this point.

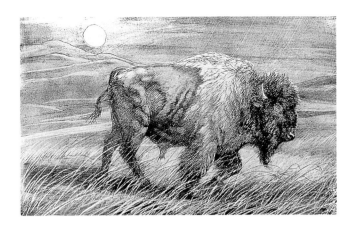

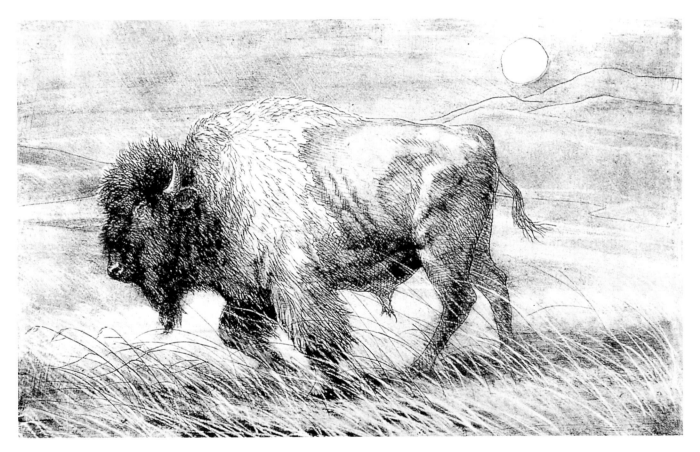

Charles Ewing *Bullish Moon*
7 x 11" (18 x 28 cm). Clay-surface lithograph.

Step 9: Printing. The print that you see, the first proof of the edition, exhibits the combination of intaglio and lithography techniques. To print, I used the same method as in the previous demo.

CHARLES EWING *Swan*
8 x 10" (20 x 25 cm).
LithoCoal powder image on white-clay litho plate.
The black lines on this plate are actually raised above the surface of the white clay. I achieve this by scrubbing the plate under the tap with a cellulose sponge. The wet clay is abraded to a level below that of the fused LithoCoal lines. This allows for easy hand printing.

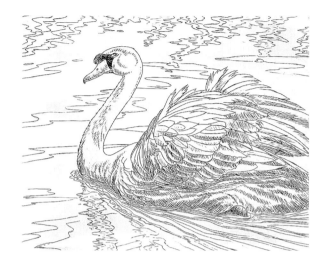

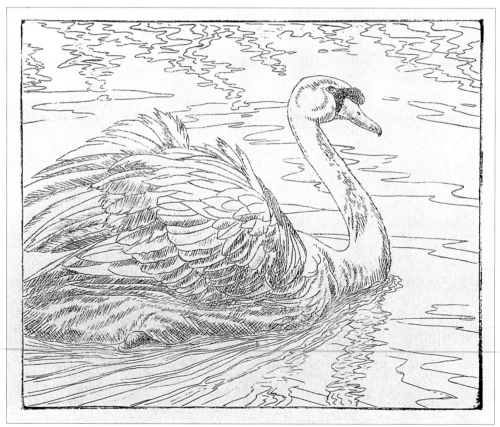

CHARLES EWING *Swan*
8 x 10" (20 x 25 cm). Clay-surface lithograph, hand-printed.
The raised ink lines on the plate facilitate hand-printing, requiring less pressure to pull ink off the plate. I used the back of a tablespoon as a baren to make this transfer. Of course, an etching press may also be used and will produce darker, more consistent prints. In the realm of lithography, the sharpness and delicacy of line is unique to this process.

Monotypes Printed on Clay

Artists who enjoy printing monotypes have wonderful new options open to them, thanks to the white-clay surface. Used instead of paper, Claybord is far more permanent; may be enhanced with painting or scratching techniques; and when sealed with acrylic varnish, these monotypes may be displayed without the distracting reflections of glass.

Original art for a monotype is typically painted on a hard plate, such as Plexiglas or styrene, which transfers paint to moist print paper that is, of course, soft and flexible. Conversely, when printing the image on the hardboard-backed clay surface, the *plate* needs to be soft and flexible. For this pur-

pose, I have found freezer-wrap paper to be an ideal painting surface. One side is coated with waterproof polyethylene plastic, providing a surface similar to Plexiglas. Original art painted on it presses easily into the clay-coated plate to transfer the image.

But oil paint—the medium generally used for painting a monotype original—does not transfer very well to clay. Oil-based printing inks do much better, but if thick blobs of ink occur on the art, they will flatten into a mess under the press. The alternative? Createx Monotype colors, a relatively new line of water-based paints, transfer nicely to the white-clay surface when used for monotype prints, as shown in the next demo.

MATERIALS

freezer-wrap paper
Createx Monotype colors with base coat
brushes
cotton swabs
scratching tools
white-clay panel
cellulose sponge
etching press (or spoon)
acrylic varnish

DEMONSTRATION: Trout Ripples

STEP 1: Painting on freezer-wrap paper.
I began by taping down freezer paper, plastic side up, cut an inch larger than the white-clay panel that will receive the print, brushed it with a thin layer of Createx base coat, and allowed it to dry thoroughly. Then I painted my ripply scene with colors by the same supplier, working with brushes of many types, cotton swabs, and various scraping tools for a variety of visual textures. When the piece is dry, it can be conveniently stored indefinitely until ready to print.

STEP 2: Transfer to clay.
I began by wetting the white-clay panel with a sponge until it was well saturated, then wiped off excess water. Then I placed the panel clay side up on an etching press bed, positioned the freezer-paper painting upside-down on the clay surface, and ran it through the press under moderate pressure. (In the absence of a press, a firm hand with a rubber roller will do the job.) After allowing it to dry, I enhance the image with scratching tools, defining highlights then with steel wool, dimming areas that might pull focus away from more important areas.

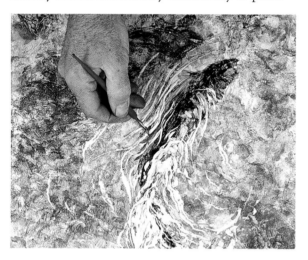

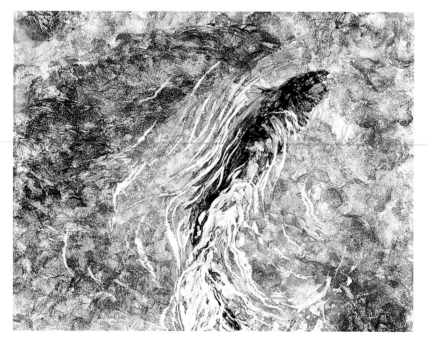

CHARLES EWING *Trout Ripples*
12 x 16" (31 x 41 cm). Monotype print on white-clay panel.

STEP 3: Sealant.
My finished monotype print is sealed with spray acrylic varnish, which not only gives the painting a washable surface but enriches its color and makes thin passages more transparent.

Colored-Pencil Monotype

Transferring art made on paper with water-color pencils to the more permanent clay surface is a useful technique to enhance display options for work that might not otherwise be shown. For example, often an artist will dash off a quick sketch of an idea, using whatever paper is at hand. Some of those casual sketches turn out so nicely, it is unfortunate when they are sketched on low-quality paper or merely a grocery sack. But if such pictures are drawn with watercolor pencils, they may be transferred easily to a permanent clay surface (albeit in reverse orientation), using this simple monotype hand-pressed technique.

Draw on virtually any type paper with crayons or pencils having water-soluble pigment.Thoroughly wet a Claybord panel,

wipe off excess water, then place the panel face up on a table. Position your sketch face down on the panel, lay newspaper over it, and firmly press the whole surface with the heels of your hands to transfer the print.

Print as many ghost-image monotypes as the amount of pencil pigment will allow. You should be able to get about three in addition to the first print, each a little dimmer than the preceding one. Of course, you will get more ghosts using darker lines in the original (and also more using an etching press versus hand-printing). Manipulate the monotype image with additional pencil work, airbrush, or with scratching or abrasive tools.

CHARLES EWING *Female Nude*
14 x 8" (36 x 21 cm) paper; 10 x 8" (25 x 20 cm).
Watercolor pencil monotype on white-clay panel.
I made the sketch on the left in a life-drawing session, using colored pencils. Then I selected a portion of the drawing to print on the Claybord panel.

Serigraphs

In serigraph printmaking, paint or ink is pushed onto paper through a fine silk or nylon screen, which is masked where no color is desired to produce the image. Using white-clay panels instead of print paper gives the serigrapher distinct advantages.

Rarely are registration problems encountered with the hardboard-backed clay surface, given its dimensional stability, even with water-based inks. Print papers often stretch, buckle, and otherwise change shape during the printing of multiple colors, making it commonplace to lose a few prints because of inaccurate registration.

And, to note once again, as with other uses of clay-surfaced panels, serigraphs printed on them may be varnished and framed without glass or matting. Frames usually chosen for oil paintings, with or without linen liners and fillets, are ideal for clay-surfaced serigraphs, definitely making them stand out from traditional ones on the wall of a gallery or museum.

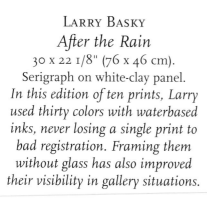

LARRY BASKY
After the Rain
30 x 22 1/8" (76 x 46 cm).
Serigraph on white-clay panel.
In this edition of ten prints, Larry used thirty colors with waterbased inks, never losing a single print to bad registration. Framing them without glass has also improved their visibility in gallery situations.

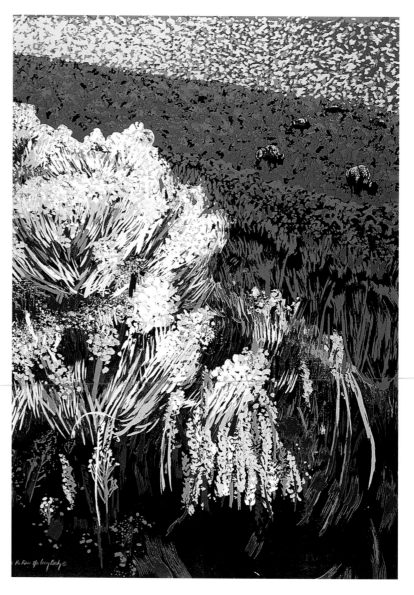

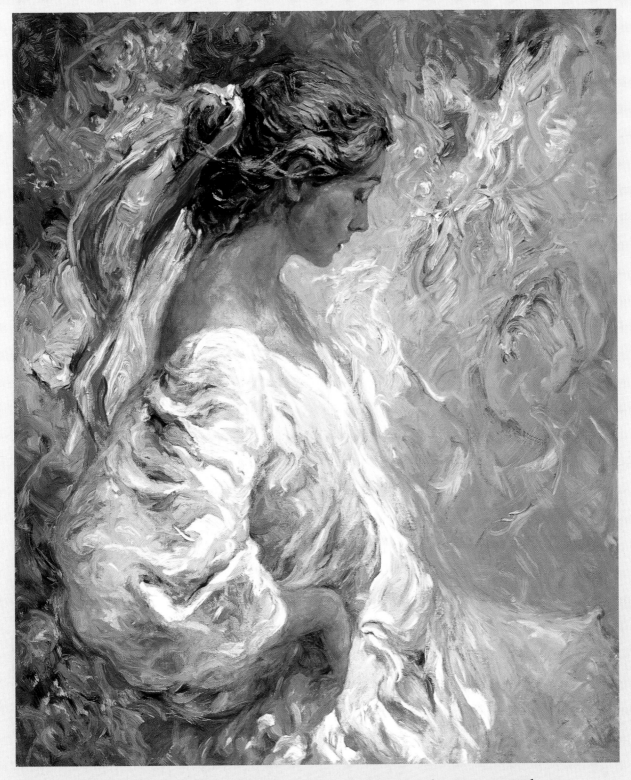

ROYO (COURTESY, TRIAD ART GROUP, INC.) *Entre Azules (Amongst Blues)*
29 x 24" (74 x 61 cm). Serigraph on white-clay panel.
*When employed commercially for serigraphed reproductions of fine art, the hardboard-backed clay surface
can faithfully reproduce more than one hundred colors per print. The permanence and lightfast nature of
the clay surface encourages longterm display of reproductions without glass protection.*

Resources for Materials

To try the many techniques, tools, and pigment mediums showcased in this book, you can obtain scratchboard and related products at numerous art supply stores across the United States and in other countries. Listed below is contact information for some of the larger American retailers and manufacturers.

If you maximize your enjoyment and success with clay-surface art by experimenting with different methods, materials, and brands, you will discover that when it comes to the infinite rewards offered by scratchboard art, the creative approaches presented in these pages have only begun to scratch the surface!

Large Retail Outlets and Catalogs

CHEAP JOE'S
374 Industrial Park Drive
Boone, NC 28607
1-800-227-2788
www.cheapjoes.com

DANIEL SMITH
P. O. Box 84258
Seattle, WA 98124-5568
1-800-426-6740
www.danielsmith.com

DICK BLICK ART MATERIALS
P. O. Box 1267
Galesburg, IL 61042
1-800-447-8192
www.dickblick.com

JERRY'S ARTARAMA
P. O. Box 58638
Raleigh, NC 27658
1-800-827-8478
www.jerrysartarama.com

NEW YORK CENTRAL ART SUPPLY
62 Third Avenue
New York, NY 10003
1-800-950-6111
www.nycentral.com

PEARL PAINT
308 Canal Street
New York, NY 10013
1-800-451-7327
www.pearlpaint.com
(stores in more than twenty cities)

Manufacturers

AMPERSAND ART SUPPLY
1500 East 4th Street
Austin, TX 78702
1-800-822-1939
www.ampersandart.com

PRODUCTS: Claybord Original (White), Black, and Textured hardboard-backed, water-insoluble, clay-surfaced panels; 5 x 7" to 24 x 36"; custom sizes up to 4 x 8'; clay mixture for texturing; various scratching and abrading tools.

BRITISH PROCESS BOARDS, LTD.
17 Lisle Avenue
Kidderminster Worcs DY11 7DE
England
American importer:
ARR-JAY PRODUCTIONS
Attn: Rudy Gothenquist
12460 NE Marine View Drive
Kingston, WA 98346
1-360-297-4455

PRODUCTS: Essdee Scratchboard, cardboard-backed, water-soluble panels, white and black-inked; 4 x 6" to 19 x 24" in two different thicknesses; scratching points and nibs.

CANSON, INC.
P. O. Box 220
South Hadley, MA 01075
1-800-628-9283
www.canson.us.com

PRODUCTS: Canson white and black-inked, cardboard-backed, watersoluble, clay-surfaced panels; 19 x 24".

CREATEX COLORS
14 Airport Park Road
East Granby, CT 06026
1-800-243-2712
www.createx.com

PRODUCTS: Monotype Colors, a new, water-based medium for monotypes, encompasses a wide range of colors.

D'UVA FINE ARTISTS MATERIALS, INC.
1900 Broadway, NE
Albuquerque, NM 87102
1-877-277-8374
www.lithocoal.com

PRODUCTS: LithoCoal in powder and compressed sticks; sumi ink; watercolors; all erasable until heat-fixed.

GRAPHIC CHEMICAL AND INK CO.
P. O. Box 7027
Villa Park, IL 60181
1-800-465-7382
www.graphicchemical.com

PRODUCTS: Printmaking inks, tusches, crayons, brayers, papers.

MICRO MARK TOOLS
340 Snyder Avenue
Berkeley Heights, NJ 07922
1-800-225-1066

PRODUCTS: Fiberglass brushes, ⅛" and ¼" wide.

PRINTMAKERS MACHINE CO.
724 North Yale
P. O. Box 7191
Villa Park, IL 60181,
1-800-992-5970

PRODUCTS: Etching, intaglio, litho, and other printing presses.

SCRATCH-ART COMPANY
P. O. Box 303
Avon, MA 02322
1-800-377-9003

PRODUCTS: Paris Scratchboard, a black-inked, cardboard-backed, water-soluble, clay-surfaced panel; also white, silver, and gold surfaces; 8½ x 11" to 22 x 28" in two different thicknesses; various scratching tools.

SUGGESTED READING

Ayres, Julia, *Monotype Mediums and Methods for Painterly Printmaking.* New York: Watson-Guptill Publications, 1991.

Curtis, Cécile, *The Art of Scratchboard.* Cincinnati: North Light, 1988.

Cutler, Merritt, *How to Cut Drawings on Scratchboard.* New York: Watson-Guptill Publications, 1960.

Heller, Jules, *Printmaking Today: An Artist's Handbook.* New York: Holt, Rinehart and Winston, 1972.

Lozner, Ruth, *Scratchboard for Illustration.* New York: Watson-Guptill Publications, 1990.

Martin, Judy, *The Encyclopedia of Printmaking Techniques.* Philadelphia: Running Press Book Publishers, 1998.

Massey, Robert, *Formulas for Painters.* New York: Watson-Guptill Publications, 1967.

Mayer, Ralph, *A Dictionary of Art Terms and Techniques.* New York: Barnes and Noble Books, 1969.

Page, Hilary, *Hilary Page's Guide to Watercolor Paints.* New York: Watson-Guptill Publications, 1996.

Peterdi, Gabor, *Printmaking: Methods Old and New.* New York: Macmillan Publishing, 1980.

Quiller, Stephen, *Acrylic Painting Techniques.* New York: Watson-Guptill Publications, 1994.

———— *Color Choices.* New York: Watson-Guptill Publications, 1989.

———— *Painter's Guide to Color.* New York: Watson-Guptill Publications, 1999.

Senefelder, Alois, *A Complete Course of Lithography.* New York: Da Capo Press, 1977.

Vickrey, Robert, and Cochrane, Diane, *New Techniques in Egg Tempera.* New York: Watson-Guptill Publications, 1973.

Wilcox, Michael, *The Wilcox Guide to the Best Watercolor Paints.* Perth, Australia: Colour School Publication, 1991.

ABOUT THE AUTHOR

Photo by David Guerrero

Art unexpectedly became a serious endeavor for Charles Ewing while he was serving in the Peace Corps in Chile. Having a Bachelor of Science degree in Wood Science and Technology, he worked in that field in Santiago, and at the same time, activated a latent interest in painting, a fascination for him since boyhood when he had watched his father, Frank, work magic on canvas.

Ewing began studying drawing and painting with Chilean artist Thomas Daskam. Soon he was able to put his talents to work with another program in Chile by illustrating that government's Department of Forestry and Wildlife *Field Guide to Chilean Mammals*. After two enjoyable years

exploring the Andes in search of indigenous wildlife to record with pen and ink and oils on canvas, he left the Peace Corps for Seattle, where he worked another two years as staff illustrator with the Department of Wildlife at the University of Washington. For that project, he began exploring the potential of the scratchboard medium, a pursuit that has commanded his interest ever since.

While experimenting with various recipes for making his own more permanent and versatile clay-surfaced panels for fine-art application, Ewing relocated to New Mexico, then to Colorado, where his connection with the force and beauty of mountain wilderness gave him a profound respect for the integrity of nature, a message that pervades his work. In addition to his wildlife subjects, his figurative work, character portraits, and landscapes in a variety of mediums have been widely admired over the past twenty-five years.

In developing clay surfaces further, about ten years ago, Ewing and his wife, Barbara, began manufacturing a line of products under the name Claybord, now marketed by the Ampersand Art Supply Company. He continues to share his successful experience with new clay materials and techniques by conducting workshops and demonstrations in many parts of the United States and abroad. Ewing's work may be seen in several galleries in the Southwest and at his home-studio gallery in Colorado's San Luis Valley.

INDEX